ALWYN CRAWSHAW'S
Watercolour
Painting Course

ALWYN CRAWSHAW'S
Watercolour
Painting Course

A STEP-BY-STEP GUIDE TO SUCCESS

HarperCollins*Publishers*

First published in 1991
by HarperCollins Publishers
London

Reprinted 1991, 1992

© Alwyn Crawshaw 1991

Designed by Trevor Spooner
Edited by Joan Field
Photography by John Philip Driscoll
Phototypeset by Southern Positives and Negatives (SPAN),
Lingfield, Surrey

**THE CIP catalogue record for this book is available
from the British Library**

ISBN 0 00 412523 1

Printed in Hong Kong

ACKNOWLEDGEMENTS

I should like to express my thanks to all the students
who, unknowingly, through their participation on my
courses over the years, have made this book possible;
Collins and in particular Joan Clibbon and Cathy
Gosling; Trevor Spooner for designing the book, Joan
Field for editing and Gertrude Young for typing the
manuscript. Finally, my wife June, who has helped and
taught with me on every course we have held.

The Travelling Studio is obtainable from Daler-Rowney
stockists or direct from the manufacturers:
Teaching Art Ltd, Westborough, Newark, Notts NG23 5HJ

CONTENTS

YOUR TUTOR

Successful painter, author and lecturer, Alwyn Crawshaw was born at Mirfield, Yorkshire and studied at Hastings School of Art. He now lives in Dawlish, Devon with his wife June where they have opened their own gallery. As well as painting in watercolour, Crawshaw also works in oils, acrylic and pastels, choosing as his main subjects, landscapes, seascapes, buildings, and anything else that inspires him. He is a Fellow of the Royal Society of Arts, and a member of the Society of Equestrian Artists and the British Watercolour Society.

Crawshaw's previous books for Collins include eight in their 'Learn to Paint' series, 'The Artist at Work' (an autobiography of his painting career), 'Sketching with Alwyn Crawshaw' and 'The Half-Hour Painter'.

In addition to a 12-part television series on TSW and Channel 4 entitled 'A Brush with Art', Alwyn Crawshaw has made several videos on watercolour painting. He has been a guest on various local and national radio programmes, including 'The Gay Byrne Radio Show' in Eire, and has appeared on television programmes including BBC Television's 'Pebble Mill at One', 'Daytime Live' and 'Spotlight South West'. He regularly organises his own successful painting courses, as well as giving demonstrations and lectures to art groups and societies throughout Britain. Heavy working horses and elm trees are frequently featured in his paintings and may be considered the artist's trademark. Painted mainly from nature and still life, Crawshaw's work has been favourably reviewed by critics. In a recent feature on the artist, the 'Telegraph Weekend Magazine' reported Crawshaw to be 'a landscape painter of considerable talent and prodigious expertise'. 'The Artist's and Illustrator's Magazine' described him as 'outspoken about the importance of maintaining traditional values in the teaching of art'.

Fine art prints of Alwyn Crawshaw's well-known paintings are in demand worldwide. His paintings are sold in British and overseas galleries and can be found in private collections throughout the world. Crawshaw has exhibited at the Royal Society of British Artists in London, and he won the prize for the best watercolour on show at the Society of Equestrian Artists 1986 Annual Exhibition. His many one-man shows in England and Germany have been enthusiastically acclaimed by both critics and the public. He is listed in 'Who's Who in Art, Men of Achievement' and the Marquis 'Who's Who in the World'.

Alwyn Crawshaw believes that if an artist first masters the rules of his craft and learns how to paint in a realistic style, he can then develop from that point.

THE COURSE

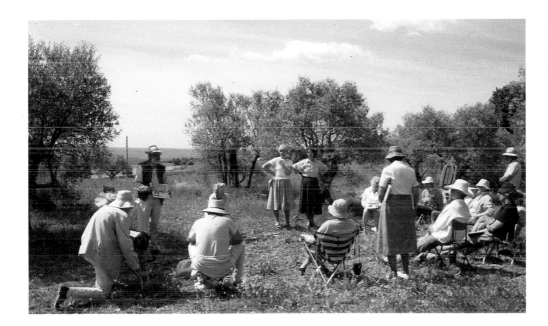

For many years now I have been organising and conducting painting courses, and I have based this book on some of those courses. The following lessons and exercises have been constructed to lead you step by step through the many phases of watercolour painting. If you are a beginner, don't worry. I won't let you run before you can walk; I don't want you to get that feeling, 'It will never happen for me, I'm not an artist'. If you take these lessons in the order I have set them, and practise and persevere, then you will surprise yourself by proving that you are perfectly capable of painting. It won't surprise me; even on a short three-day course, I have watched students make progress and sometimes surpass my hopes. Naturally, with me 'hovering' around them the incentive is greater – or is it fear? Still, I am sure you can do as well without my being there, and some of you may do better!

If you already paint in another medium and you are going to try watercolour, then I suggest that you, also, start at the beginning. Don't assume that a particular technique or way of working is the same as in your present medium. It may or may not be, so read everything. If you are a student who already knows the basics of watercolour, I am sure there is still plenty to learn on this course; we all learn something more with every painting we do.

On all of my courses, whether they are one day or two weeks long, June, my wife, who is a fine watercolourist, helps me and we work as a perfect team. So when I refer to June or 'we' in the text you now know who June is and that she isn't a figment of my artistic imagination!

The first part of the course always starts indoors. This means that you are in control of your painting conditions: subject, light, comfort, warmth and all the necessary physical elements that you need to obtain the best results. This is very important, especially for the beginner, for whom we must eliminate as many problems as possible. When students have overcome their 'first night nerves' and are feeling more confident in themselves and their work, we then go outdoors to work from nature and also to learn to cope with the elements. This book has been structured in exactly the same way.

Obviously, when you are following a written course you cannot ask questions, so please read through the whole book first, before you start to paint. I am sure you will find it helpful.

What I want this book (course) to do is to give you confidence and to put you firmly on the road to successful watercolour painting. But above all, to give you inspiration, the will to practise and succeed. I know that together we can do it.

Good luck!

Alwyn Crawshaw

THE EXCITEMENT OF WATERCOLOUR

It is difficult for anyone not to become excited about doing something creative. The joy of making something with your hands – a model, a flower-arrangement, a delicious meal – whatever it is can be the height of satisfaction. Well, painting a picture is just the same.

Many years ago, I saw a calendar depicting four heavy horses ploughing. I was so inspired and excited about it that the next day I started to enquire where I might find some heavy horses to paint. Eventually I was told of a farm where there were three working horses and I went along and sketched them. I have enjoyed painting horses ever since.

Of course, Nature herself can be a source of inspiration. You must have experienced times in the countryside when the air you breathed smelled so wonderful that you could have eaten it; the warmth of the late-afternoon sun and the mellow odour of newly-fallen autumn leaves combining to give a tremendous feeling of joy. But then that moment passes, gone forever, as you move off in the direction of your parked car.

Now, if you were painting it, you might take one to three hours, or longer, depending on the subject and the size or type of watercolour you were doing. During this time you would be focusing all your attention on the scene. Every time you looked at the painting at home, perhaps years later, those few hours would come alive again: you would remember the couple walking their dog, who passed just as you were painting the fence at the side of the tree, or the rabbit that peeped out from the hedge, looked at you and quickly hopped away just before you started to paint the farm in the distance.

Fig. 3 Cartridge paper, 27 × 18 cm (10½ × 7 in)

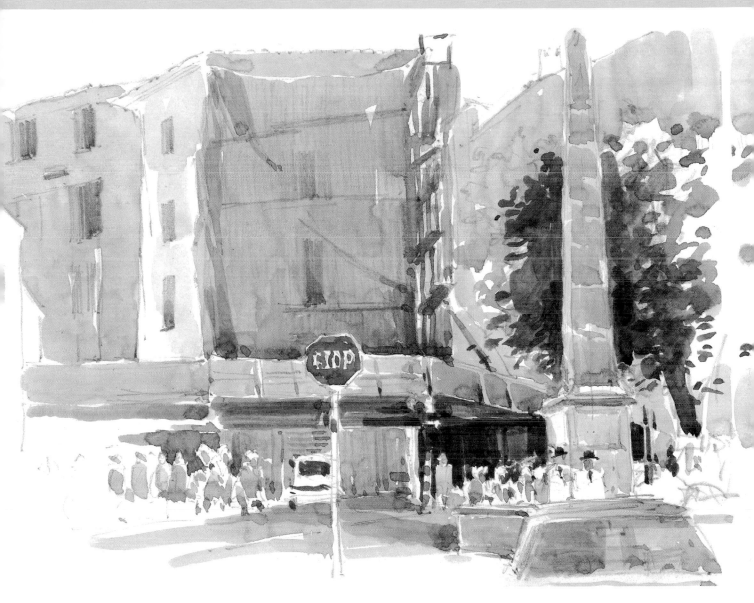

Fig. 4 *From the square, Forcalquier, Provence.*
Cartridge paper, 29 × 21 cm (11½ × 8¼ in)

I find it very difficult to sell some of the paintings I have done on location, simply because of their memories. In fact, I do keep some of them as my 'specials' and I shall never sell them. The sketch in **fig. 144** on page 106 is one of them. It is a very simple study of boys fishing on a five-foot wide sea wall. June and I had gone down to the beach with our sketchbooks and started to paint the boys. Looking out to sea, we watched a mist roll in, and within five or six minutes of first spotting it, we couldn't see the boys on the end of the wall. We (and the diehard fishermen) moved back to the safety of the town, and we gave up the idea of any more sketching: the nearby Victorian buildings looked very mysterious, looming out of the mist, and made an inviting subject, but the watercolour paint wouldn't have dried because the

heavy mist made the atmosphere too damp. In fact, I had to walk with my pad open for 20 minutes before the paint on the sketch of the boys was dry.

The painting in **fig. 4** was done as a demonstration for 18 students on a painting course which June and I held in Provence. It was the first day, and the students were not very impressed by the view. The building behind the Stop sign was being renovated and was clothed in semi-transparent green nylon sheeting which covered the lovely old stonework. But the whole scene inspired me and there was much to learn from a demonstration of this subject: plenty of moving traffic, a lot of people, but I think the most important point was that wherever you are there is nearly always a subject to paint.

I purposely left the colouring of the red Stop sign until the end, and asked whether I should put it in. Seventy per cent of the students said 'No!'. But I explained that part of the inspiration had come from

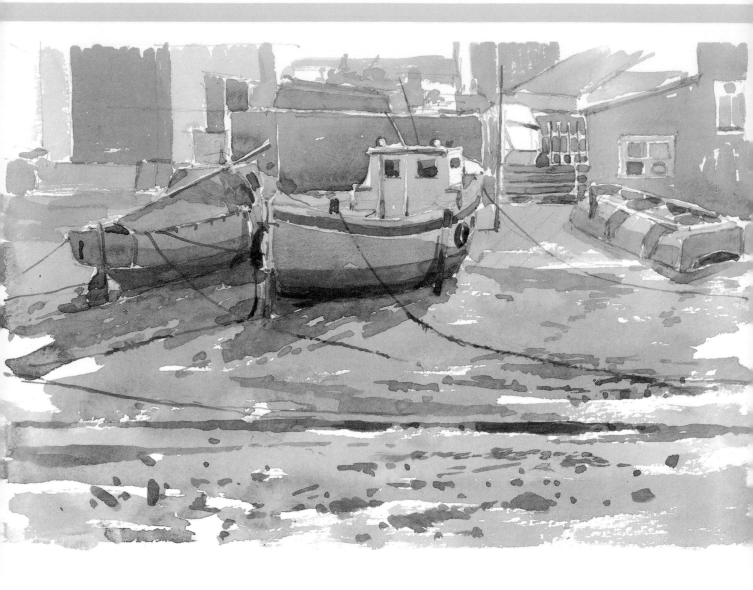

the splash of red colour prominently positioned in the scene. So I held my breath (it might not work!) and put it in. It did work, and the students agreed – thank goodness. We were off to a good start!

The great advantage of painting as a leisure activity is that you can paint outdoors in good weather, indoors on cold winter days, at home or on holiday – in fact, you can paint almost any time, anywhere. You can paint by yourself or with a friend or a group. Subjects can be found anywhere, and you will never stop learning.

You can also join your local art society. They are stimulating and informative, and, of course, you make friends with people who have the same interest as yourself.

As you become more involved with painting and your observation gets keener, you will see nature quite differently. The countryside will come alive. You will see things you never noticed before; you will get

Fig. 5 (above) *Exmouth, Devon.* Bockingford 200 lb, 28 × 18 cm (11 × 7½ in)

Fig. 6 (opposite) Cartridge paper, 29 × 21 cm (11½ × 8¼ in)

excited by a sky which, before you started to paint, you may never even have noticed. You will see reflections in water, sunlight hitting leaves on trees, soft cool colours on distant hills, sudden changes of light that last for only seconds but are breathtaking and memorable. All these things are there for us to enjoy, but we must train ourselves to observe and see them.

The painting in **fig. 5** was done at Exmouth harbour as a demonstration on one of my courses. I was happy with the painting, but feel that the mooring ropes are rather too dark (strong).

Fig. 6 shows, in a simple on-the-spot sketch, how brush strokes can help to define form, in particular in the foreground field. It is only the direction of the very

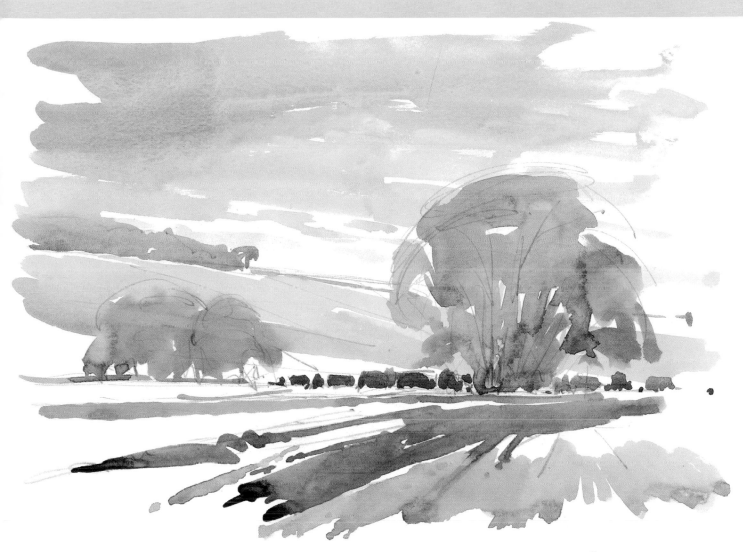

free strokes that give the field a flat look and the impression of distance. I make no excuses for the simplicity of this sketch, as I was half-kneeling at the side of a student, reaching over her legs to get to her paints with one hand and holding my pad in the other. I was working very quickly because the cows were heading our way. Mind you – my first golden rule for students is that you must be comfortable before you start to paint!

A sketch I made of a student working in a poppy field in Provence is shown in **fig. 9** overleaf. It was a very hot day and we were all in a small coach, driving along narrow country lanes as I searched for the 'spot for the day' for painting. We all noticed a farm in a shallow valley and told our driver, a very helpful Frenchman. As we reached the farmyard, ducks, geese, chickens and four very angry-looking farm dogs were scattered everywhere in clouds of dust. After a lot of French gesticulation and non-stop talking between the

Fig. 7 Pencil on cartridge paper, 29 × 21 cm (11½ × 8¼ in)

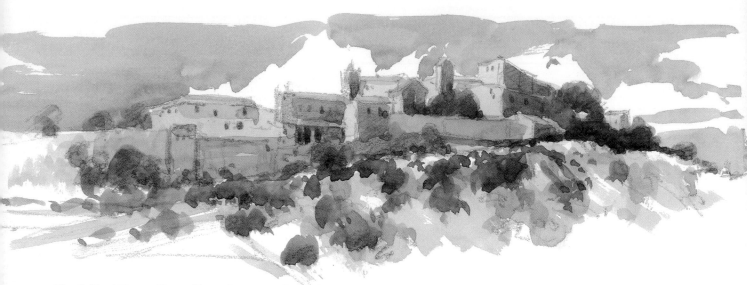

Fig. 8 *The hilltop village of Lurs, Provence.* Cartridge paper, 29 × 21 cm (11½ × 8¼ in)

farmer and our driver, a smile swept over the farmer's face and he asked where we would like to paint. Eventually we found a fabulous spot overlooking the farm and valley, where we sat and painted, surrounded by poppies and herbs.

I am often asked which season I like the best. Well, the answer is simple. When I am painting in the summer – as in the poppy field in Provence – I think it is the only time to paint; why have other seasons? Then when the summer goes and it's the autumn with its soft, warm subdued colours, I love it; why get excited about the summer? And so to winter, and the same applies. I like every season as I paint it, and as I paint I believe it's the best season of all, until the next one . . . I suppose what I am saying is that I like painting. So let painting be your first love, then you will find subjects to paint everywhere. Naturally, you will find some more inspiring than others, but don't be afraid to experiment with different subjects. Eventually, you will find one that you prefer to any other, and that's natural, but do keep an open mind and try others.

As you work through this course and copy exercises

from these pages, you may be inclined to copy my style of working. There's nothing wrong with that. But if you find that your own style is trying to come through – and it will – then let it. We all have our own way of working – how we mix the paint, move the brush, or how we apply ourselves to painting, how we see the subject – and this natural style must be allowed to emerge.

Take each lesson in your own time; there are no prizes for speed. If you find one difficult, you can move to the next, but don't go too far ahead. The most important thing is to practise and persevere. It will happen in the end. With some students it may be only days before they see results that please them. With others it may be weeks. And it doesn't matter how long it takes, so long as you enjoy doing it.

The sketch at the top of the page, **fig. 8**, is one I did from an olive grove when the students gave me fifteen minutes' break! So be warned – painting is catching. Once you've got it in your blood, you can't stop.

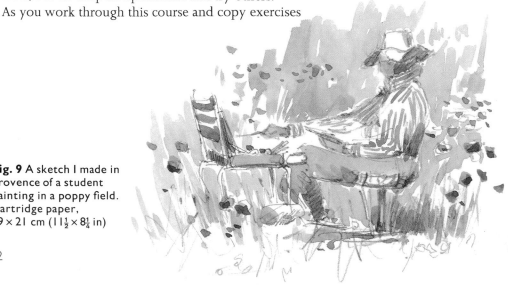

Fig. 9 A sketch I made in Provence of a student painting in a poppy field. Cartridge paper, 29 × 21 cm (11½ × 8¼ in)

Part One
THE BEGINNING

MATERIALS

Naturally, the choice of materials is a personal matter, and when you have gained experience, you will make your own decisions. In the meantime and for this course, if you are a beginner, I suggest you use what I use. And remember, to get the best results you should use the best materials you can afford.

Colours

There are two types of watercolour paint: the difference is in their quality and cost. The best are called Artists' quality Water Colours and those a grade lower are called students' watercolours, some of which are manufactured under brand names such as Georgian Water Colours. You can buy watercolour boxes either already filled with paints or empty, ready to fill with colours of your choice. (**Fig. 15**, page 16, shows my box: the colours I use are discussed in Lesson 2.)

The watercolour pans are made in two sizes: a whole pan and a half-pan (**fig. 10**). My box in **fig. 15** is filled with Artists' quality whole pans. Watercolour paint also comes in tubes (**fig. 10**) but I do not advise beginners to use these: because of the strength of the pigment in Artists' quality colours and the soft consistency of the paint when squeezed out on to the palette, it is difficult to control the amount of paint picked up by the brush. The pigment in students' tube colours is not so strong, so you may be happier using these. But my thoughts are clear: for beginners I recommend Artists' quality pans (whole or half pans) in a watercolour box.

For most of my small outdoor work up to 28 × 41 cm (11 × 16 in) I use the Travelling Studio which I designed and which is now on the market (**figs. 12–14** opposite). It is totally self-contained. The shoulder-strap round my neck supports the kit, the water cup is held firmly on the tray, next to the paint pans, and my left hand supports the pad. You can even stand up and paint with this kit – I never go anywhere without it. The contents are: six Daler-Rowney Artists' quality Water Colours (my colours) in a removable aluminium paint box, a No. 5 sable brush, a spiral-bound Bockingford Watercolour Paper pad 13 × 18 cm (5 × 7 in), and a pencil. It has a rustproof water bottle and water-cup holder. All this is neatly held together in a tough PVC waterproof case with carrying-strap and weighs only about 500g (1 lb).

Brushes

It is hard to separate colours, brushes and paper in order of importance but I feel that the brush must just

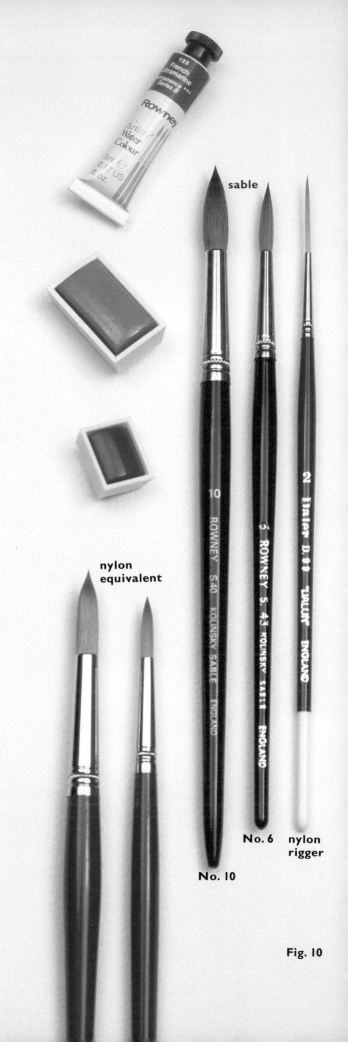

sable

nylon
equivalent

No. 6 nylon
 rigger

No. 10

Fig. 10

make the top of the list. It is the brush that makes the marks that we create, and these build up to make a painting. What type of brush we use and how we apply the paint with it determines our individual style.

For watercolour painting there is only one general-purpose brush that a traditionalist would use and that is a round sable (**fig. 10**). I agree; with this type of brush a watercolour can be created as fine as any of the Old Masters' paintings, as these were the brushes they used, but I must add that to paint like them there must be a little more magic in the hand that holds the brush! These brushes, which will last for years, are at the top of the price range, but modern technology has stepped in to help.

Man-made fibres (nylon) are now used to replace the sable hairs in artists' brushes, which makes them much less expensive. Many are sold under brand names. In **fig. 10** two Dalon brushes are illustrated on the left, the same size as the sable ones on the right. To me the most important difference between nylon

(Dalon) brushes is their water-holding ability. A nylon brush holds only about two-thirds of the amount of water held by a sable, and that is important as you will find later. But I do find the smaller sizes of nylon brushes excellent for detail work. **Fig. 10** also shows the nylon (Dalon) rigger brush I use. In fact, the three brushes illustrated on the right of **fig. 10** are the only brushes I use for all my watercolour painting. If you find your bank manager won't allow you to buy sable brushes, don't worry: I know professional artists who use Dalon brushes for their watercolour painting and they are happy.

Fig. 11 (below) The large pockets of my painting waistcoat hold everything I need for painting outdoors

Figs. 12, 13 and **14** (right) The Travelling Studio is indispensable for outdoor work: you can even use it standing up

Paper

Which paper should you choose? This is a vast subject, but to simplify matters I have assembled pieces of the different papers I used for this course (**fig. 16** opposite) and indicated their names, grades and weights. I have also shown you what effects a pencil and a brush stroke of colour give you on each type of paper, reproduced actual size.

The grade of the paper simply means the texture of the working surface. Traditionally there are three different surfaces: Rough, Hot-pressed and Not. Rough means that the surface is rough; Hot-pressed (HP) means the surface is very smooth; and Not (sometimes called Cold-pressed or CP) indicates that the surface is in between rough and smooth – by far the most commonly used. The weight of the paper (the thickness) is determined either by grams weight per square metre (increasingly the most common method) or by calculating how much a ream of paper (500 sheets) weighs. So, if a ream weighs 300 lb (which is about the heaviest paper you can use), the paper is so called (with its manufacturer's name and surface type) – for example, Whatman 200 lb Not. You will find that a good weight of paper to work on is 140 lb (285–300 gsm).

Bockingford watercolour paper doesn't have a surface title, being made with only one surface, but it has different weights and is an excellent inexpensive watercolour paper. The other papers shown are traditional papers with three different surfaces and different weights; they are a little more expensive than Bockingford or cartridge paper.

The secret of finding the right (not necessarily the best) paper to work on is to try out different ones until you discover which suits you. Then use it, practise on it and get to know it. When you have learned how your paper reacts when you paint on it, you will be well on the way to mastering watercolour painting.

If you are a beginner, try the papers illustrated in **fig. 16**. A good art supply shop will sell them in pads of various sizes, or in sheets, usually 51 × 76 cm (20 × 30 in). I find cartridge drawing paper is lovely for painting small sizes, say up to 28 × 41 cm (11 × 16 in). I suggest you get a sketchpad of this paper. It is also the paper commonly used for drawing.

Basic kit

The basic materials you need to start watercolour painting are shown in **fig. 15**. 'Basic' does not refer to their quality but to the minimum quantity necessary to enable you to follow this course. As you gain experience you can build up this basic kit to suit your own requirements. In **fig. 11** on page 15, I am wearing my painting waistcoat for outside work. It carries all the materials I need as a professional – and many more – extra paints, brushes, pencils, a putty eraser, a knife for sharpening pencils, spare rubber bands to hold the sketchbook pages down, a box of sticking plasters and aspirin – you never know what may happen! If I am just doing small work outside I use the Travelling Studio; this, with a few additions, could be your basic kit.

This is all you need: paint box to hold a minimum of six paints, whole- or half-pan size; three brushes – a No. 10 and a No. 6 round sable, or a No. 10 and a No. 6 Dalon (nylon), and a Dalon Rigger Series D.99 No. 2 (the very thin one); an HB pencil and a 2B pencil for sketching, a putty eraser, a water-carrier, a water 'jar', and paper on a drawing board or a pad. Don't forget a folding stool for sitting on. When I am working outside I don't work larger than 38 × 51 cm (15 × 20 in) and I rest the board with my paper on my knees; indoors I use a table to work on. I do not use an easel for normal work, but if you prefer to use one, then go ahead.

Fig. 15 (right) The basic materials you need in order to follow this course. Alternatively, you could use the Travelling Studio (page 15) with a few additions

Fig. 16 (opposite) Some papers suitable for watercolour painting

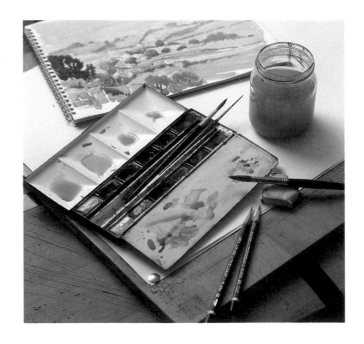

Whatman 200 lb Not HB pencil

Whatman 200 lb Rough HB pencil

Whatman 140 lb HP HB pencil

cartridge drawing paper 70 lb 2B pencil

Bockingford 200 lb 2B pencil

Waterford 300 lb Not HB pencil

GETTING TO KNOW WATERCOLOUR

Well, let's start. For those students who are familiar with watercolour, read through the next couple of lessons and start to practise when you reach the point where you feel you should. On my courses, for the first two hours, everyone has to paint a simple still-life such as a flower, a banana, an apple – something relatively quick to draw and to paint. But I spend the first 20 minutes convincing half the students that it is important to paint still life. (Why do people think it's boring?) The reason for this is to enable me to see the level of each student's ability. If they painted something from imagination or copied a photograph, then this would give me only half the information. To draw from life you need to be able to observe: the proportions, shapes, colours, tones and so on. When something is painted from memory, there is nothing for me to relate to the painting. I can't see the subject in someone else's imagination, consequently I am unable to judge a student's ability.

When everyone has finished their painting and relaxed, their shattered nerves quickly recovering with a few jokes and a cup of hot tea, I then know at what level I have to take each student forward. However, that's one exercise you don't have to do, and I must assume that you will start at the appropriate place. If you have any doubt, start here with Lesson 2.

Although you are not with a group of students, you do have to contend with your family, and that can be a little daunting. The trouble is that we all want to paint a masterpiece the first time we have a paint brush in our hand. Well, that's impossible. Remember when you first tried to swim, ride a two-wheeled bicycle or drive a car – it didn't happen overnight! Painting is no exception.

We will take it stage by stage, for if you don't you'll probably try to paint a complicated scene, with disastrous results. You'll realise that your family is taking an interest, and they'll be the first to let you know that you can't paint! This has put many people off painting, sometimes for good, so it is imperative that you start at the beginning and progress at your own speed through the lessons.

The first thing to do is to put some paint on to a piece of paper. That sounds obvious and simple, but one of the biggest psychological stumbling-blocks is actually to put paint on paper for the first time.

What I want you to do first is to buy some paper – cartridge paper, or even a roll of decorators' lining paper. You need plenty of inexpensive paper to work on. If you started to practise this lesson on expensive watercolour paper, you would make only a few doodles and brush strokes, and then say 'That's it', simply because it would be difficult for you to 'waste' expensive paper. The object of this lesson is to introduce you to the way watercolour paint reacts on paper, how a brush is worked, how colours run together, how you feel when using a brush, what happens if you mix this colour with that colour, and so on. You must not feel inhibited in doing this, and you must find time to do plenty of it. Just get the paints out, use plenty of water, and have a go.

If the family look at what you are doing and laugh, then laugh with them. After all, what you are creating will look funny. Then show them my **fig. 17** and let them laugh at that!

When you feel at home with a brush in your hand and paint at your side, and nothing seems strange to you, then you are ready to enter into a new world of great pleasure and fulfilment; but remember, this can only be achieved by practice and perseverance.

Fig. 17 The best way to get to know watercolour is to buy plenty of inexpensive paper and spend some time, as I have done on the opposite page, just doodling: finding out how the paint behaves on the paper, how the brush feels in your hand, how colours mix and run together

WASHES

Learning to paint a wash (an area of paint) on to paper is the most important and fundamental lesson in watercolour painting. A wash can cover the whole of your paper or an area only the size of a small coin.

Before you start, there is one important rule to learn concerning the angle of the paper. When you were doing your doodles I purposely didn't tell you how to position the paper as you worked on it. Some of you would have had the paper flat on a table, and others would have found that if the board was at a slight angle, the paint ran down slowly and spread as the 'watery' paint was applied, and, of course, some of you would have tried it both ways.

Well, you may have created a few special effects with the board flat, but at this early stage of your painting career, don't even think about it. **The paper must always be at an angle** when you work – not flat. The paint must be allowed to run very slowly down the paper. Some artists use an easel and have the paper upright, which is fine for those who work freely and accept that the paint can run out of control down the paper – at any time – during the painting. But before you are ready to try the flat or upright positions, you must learn how to apply and control watercolour, so your paper must be at a slight angle.

In **figs. 19** and **20** you will notice two arrows. **In all instructional illustrations I have used arrows to help you understand the movement of the brush**. The solid black arrow shows the direction of the brush stroke, and the outline arrow shows the direction in which the brush is travelling over the paper. For example, **fig. 19** shows the brush stroke moving horizontally from left to right, and the brush moving down the paper after each horizontal stroke.

The secret of applying a flat wash (**fig. 19**), apart from having the drawing board at an angle, is to use a lot of water. If you don't do this, you will find it impossible to put on a wash. Mix plenty of watery paint in your palette and load your large brush. Start at the top left-hand side of the paper if you are right-handed, taking the brush along in a definite stroke. Don't panic or rush. When you get to the end, lift the brush off the paper, bring it back to the beginning and start another stroke, running it into the bottom of the first wet stroke. Add more paint to your brush as you need it; don't let it get dry.

Because you mix the paint first and don't add any more water or paint to the mix, the colour remains the same throughout the wash. When it is dry, the colour

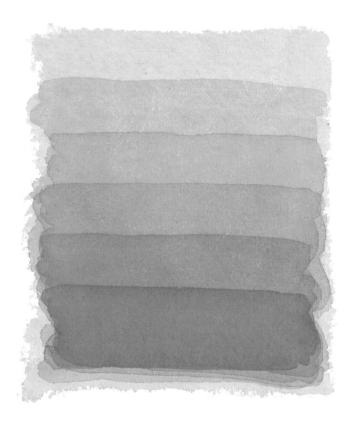

density should look the same all the way down.

Now try a graded wash (**fig. 20**). Start in exactly the same way as for the flat wash but, as you paint down, add more clean water to your paint in the palette for each brush stroke. This will make the colour weaker. As you work down, adding more water to the palette for each brush stroke, the wash will grow gradually lighter in colour until, if you keep adding water and your paper is long enough, the wash will finish up as white as the paper you're working on.

If you paint into a wash that is still wet, you will not be able to get a clean edge; the paint from your brush will run into the wet paint on which you are working. If the wash is dry, then you can get a clean edge, because the paint from your brush will not run into the dry paint of the wash. Watercolour is transparent and therefore, if you apply a flat wash, wait for it to dry and paint another over the top with the same colour, it will look darker. If you let that dry and paint over both, the result will be darker still. This is how we can build up our tonal values in a painting.

Do what I did in **fig. 18**. Mix your colour and each time you put on a wash, leave about half an inch of the

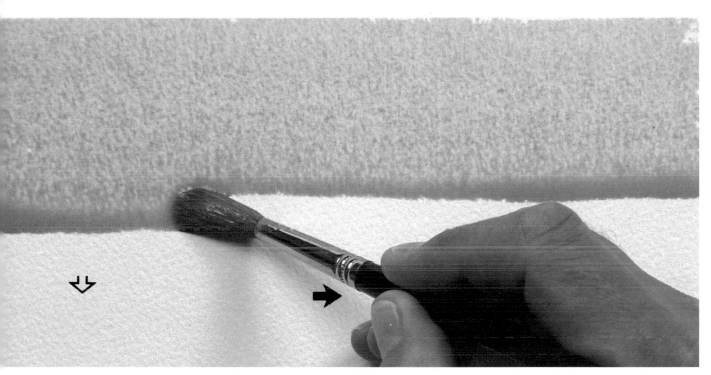

Fig. 18 (opposite) Tonal values built up by painting one wash over another after the first wash has dried

Fig. 19 (above) Flat wash: Mix plenty of watery paint in your palette before you start

Fig. 20 (below) Graded wash: For each brush stroke add more clean water to the mix in your palette

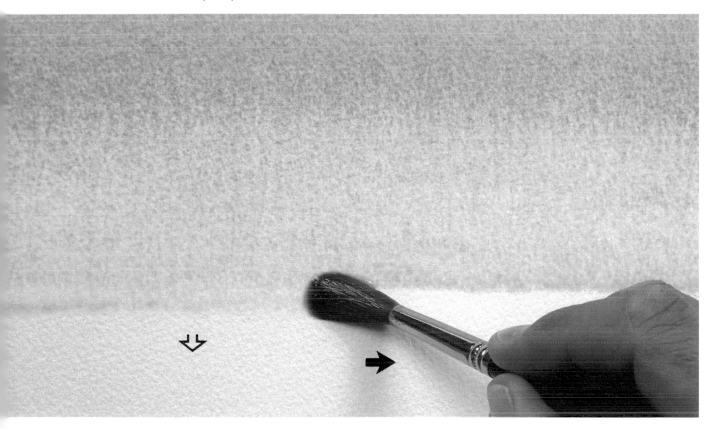

previous one showing. You will see how you darken the colour the more you progress, and also how you can get a clean-edged line.

Now let's see what happens when we paint wet paint into wet paint, using different colours. This technique is called wet on wet (**fig. 21**) and is used by many watercolourists. It is often used to start a painting and, in putting the first washes of paint on, the wet colours are allowed to mix as they are painted quickly over the paper. Here's something else you must not forget: as soon as the 'liquid look' goes off the wet paint, or it has a dull damp look, it is still wet technically but not wet enough to paint into. At this point you can't touch it again, without spoiling it, until it has dried. In **fig. 21** I painted a wash and while it was still very wet I added some more paint, and you can see the result. This could not have been achieved if the first wash had been dry. One of the nicest things about wet-on-wet work is the way the paint behaves. You are not in complete control and you can achieve some exciting results. I use it frequently for cloudy skies because the colours blend together in a very soft and delicate way.

There is another way of painting wet on wet, and that is first to wet the paper with your brush where you intend to paint. Then, when you work your colours on to the wet paper they run and mix fluidly. Again, I sometimes use this method for painting skies. If you have a sky you want to paint and you don't want the background to be touched, brush some water up to the drawn edges as if you were painting, then, when you paint the sky over the wet paper, your colours will run and blend together perfectly but will stop naturally at the dry paper. I did this in **fig. 22**.

You can't practise these washes enough. Try some with your smaller brushes; try variations of mine. I suggest that, as soon as you can, you work these washes on watercolour paper because it will give the best results. Remember – use plenty of water.

In **fig. 23** I have illustrated what can go wrong and why – I won't say which was real and which I simulated! It can happen to all of us.

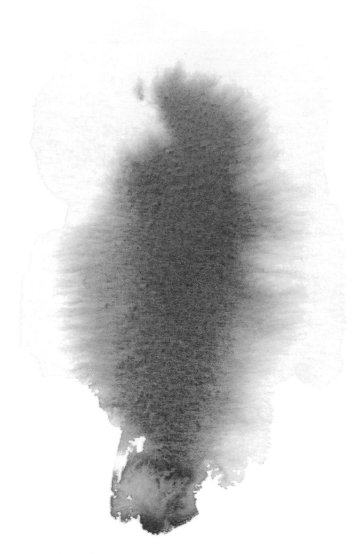

Fig. 21 One of the nicest things about wet-on-wet work is the way the paint behaves. You are not in complete control and you can achieve some exciting results

Fig. 22 A wash applied over an area of wet paper, up to a dry edge, is a useful technique when you don't want the wash to spread over an adjacent area

WHAT WENT WRONG
AND HOW TO AVOID IT NEXT TIME

Fig. 23

a Flat wash. Insufficient paint mixed: the wash was left to dry during application. Mix plenty of paint for your washes

b Flat wash. The board was tipped up too steeply, which allowed the paint to run down the paper too quickly and out of control. This also resulted in the excess build up of paint at the bottom of the wash which ran back up the paper when drying and ruined the flat wash. Keep your board at a shallow angle

c Flat wash. Insufficient water: the paint was scrubbed on. Use plenty of water

d Second wash on dry flat wash. The first wash was not dry enough; the bottom line spread more because all paint runs down the paper so the bottom of the wash stays wet longer. Wait until the first wash is dry

e Water brushed up to the edge of buildings. Not done carefully enough: water ran over the edge of the drawing, so the paint ran into the buildings

COLOURS AND HOW TO MIX THEM

There are only three basic colours – the primary colours – from which to work: red, yellow and blue. From these three, any colours can be mixed. There are, of course, different reds, yellows and blues which help you with your colour mixing. The colours I use are illustrated in **fig. 24**. My main primaries, which I use for about three-quarters of all my paintings, are: Crimson Alizarin, Yellow Ochre and French Ultramarine. I use smaller quantities of three other primaries: Cadmium Red, Cadmium Yellow Pale and Coeruleum Blue. You can buy ready-mixed shades of green, orange, purple, brown and so on, but I usually use only three of these: Hooker's Green No. 1, Burnt Umber and Payne's Grey.

My main primaries will make all the colours and tones I need, but for 'local' colours – the colour of a boat, a car, a person's dress, a daffodil – which are colours of specific objects that I want to paint exactly the same colour as they appear in real life – I may have to use a ready-mixed colour. However, for the majority of my watercolours I use only those colours illustrated in **fig. 24**.

One of the most important rules for mixing colours is to put into the palette first the predominant colour that you are trying to create. For instance, if you wanted a yellowish-orange, you must put the yellow into the palette first, then carefully add a little red. If this is done in reverse, the red overpowers the yellow and you obtain a reddish-orange. If you do not follow this simple rule, the amount of extra mixing, frustration and ruined paintings that result can put you off colour mixing – for ever!

Because watercolours are transparent, the only way

to make a colour lighter is by adding more water, to dilute the pigment (colour). To make a colour darker, apart from adding more washes over existing ones as I did in Lesson 3, **fig. 18**, just add more pigment.

Another important rule: always have your colours in the same position in your box, and your box always in the same position by your side when you work. There's enough to concentrate on without wondering where you put Yellow Ochre today! But of course, like most rules, this is just common sense.

In the colour chart opposite (**fig. 25**), I have started with my three primary colours and mixed them to show you some of the basic colours that can be obtained by mixing just two and three primary colours. Then I have added Hooker's Green No. 1, and also shown how to mix a 'black'. I don't use ready-mixed Black and I recommend that you don't, especially at the beginning: it can become a short cut to darkening colours but it will only make them 'dirty', and you will not learn how to do it by using only your three primaries. Some people find it easy to mix colours; it comes naturally to them. Others find it more difficult. All I can say is, practise; it is something that we can all learn to do. There's nothing mysterious about it.

Sit down indoors and look around you. Try mixing the colour of the wallpaper, the cushion, anything you can see. Remember, the first colour you put in your palette to mix into must be the predominant colour.

When you are mixing colours for this course, it is important to note the first colour that I specify (printed on the exercises, or mentioned in the text) as this is usually the main colour of the mix, with other colours added in smaller amounts.

Fig. 24 The colours I use. The percentages indicate the approximate amounts of each colour used for a typical painting

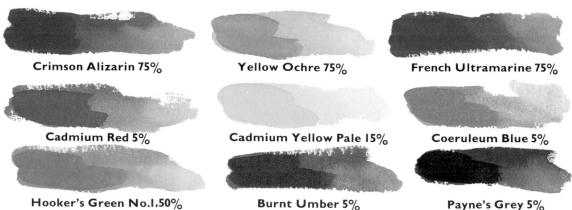

Crimson Alizarin 75% Yellow Ochre 75% French Ultramarine 75%

Cadmium Red 5% Cadmium Yellow Pale 15% Coeruleum Blue 5%

Hooker's Green No.1, 50% Burnt Umber 5% Payne's Grey 5%

THREE PRIMARIES

Fig. 25 Colour chart showing some colours that can be mixed using two and three primary colours

Cadmium Yellow Pale | French Ultramarine | Crimson Alizarin

add more water | add more water | add more water

add more water | add more water | add more water

add more water | add more water | add more water

Hooker's Green No. I | 'Black' mix all three colours

add Crimson Alizarin | add more water

add more Crimson Alizarin | add more water

Cadmium Yellow Pale add French Ultramarine | French Ultramarine add Crimson Alizarin | Crimson Alizarin add Cadmium Yellow Pale

add more French Ultramarine | add more Crimson Alizarin | add more Cadmium Yellow Pale

add more French Ultramarine | add more Crimson Alizarin | add more Cadmium Yellow Pale

add more French Ultramarine | add more Crimson Alizarin | add more Cadmium Yellow Pale

yellow, red, blue | red, yellow, blue

add more blue | add more blue

add more water | add more water

add more water | add more water

25

BRUSH STROKES

Now it's time to look more carefully at what the brush can do. Already you are familiar with it, either for mixing paints or applying paint to paper. It is possible to make a great many different brush strokes but, to simplify things, I have selected 12 basic ones which I believe will teach you as much brush control as you need, bearing in mind that you can use your own ideas to vary them. These strokes are illustrated in **figs. 26** and **27** on pages 26–9, and under each one I have painted an example of a beginner's most common mistake. I have used my No. 10 sable brush for some strokes and my No. 6 sable brush for others but, naturally, you can make any of the strokes with any brush. Add more water to obtain different effects, try different brush sizes (mine are reproduced actual size) or make up your own strokes. If you find that, to get the same results as I do, you have to hold your brush differently and you find it easier, then go ahead; your way is correct for you. I can only give you a starting point to help you. If you don't change anything, that's fine. Don't throw away your results. Keep them for reference and use them to remind you of what you can achieve.

If you find some of these brush strokes difficult at first, practise them and they will soon develop. If you

Fig. 26 Using your No. 10 sable brush

a Your brush will make this line naturally when you paint horizontally, using medium pressure

b The brush is held differently here. I use this stroke when I want to keep a definite edge at the top. The underside is uneven

c Here the brush is held and used in exactly the same way as in **b**. At the end of the horizontal stroke your brush will be flat; keep it flat but turn it on its edge and use it to paint downwards. This gives a neat edge to the end of the area you are painting

d The dry-brush technique. Load your brush with only just enough paint, so that it will start to run out during the brush stroke, creating the characteristic hit-and-miss effect. You will need a lot of practice before you are able to judge how much paint to use, so keep at it

e A good brush can cope with this technique without any problem. Push the brush hard on the paper, then push it upwards, letting the brush hairs splay out in all directions. You will automatically get dry-brush effects this way. I use this technique for foreground grass, hedges, etc.

f Use this stroke to fill in a small area, when three sides are to be kept within a given shape, e.g. for chimney stacks

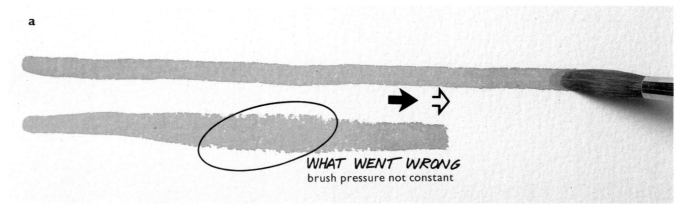

a

WHAT WENT WRONG
brush pressure not constant

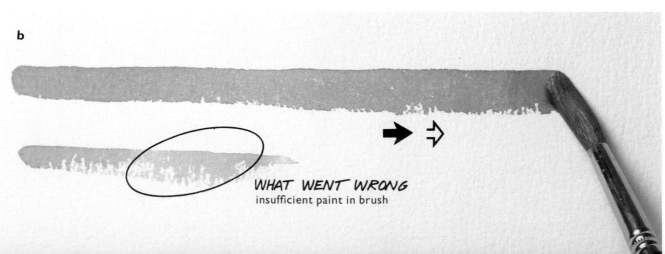

b

WHAT WENT WRONG
insufficient paint in brush

c

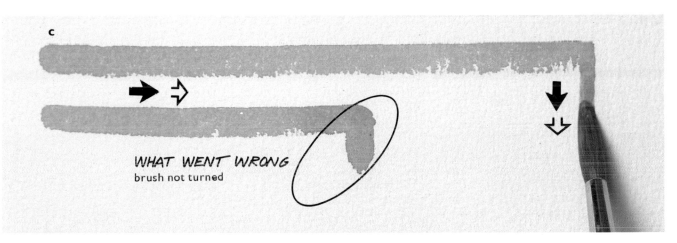

WHAT WENT WRONG
brush not turned

d

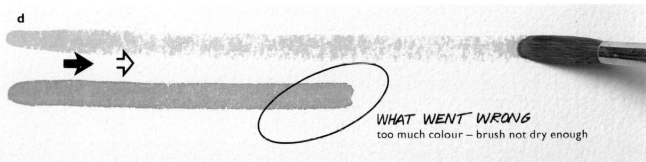

WHAT WENT WRONG
too much colour – brush not dry enough

e

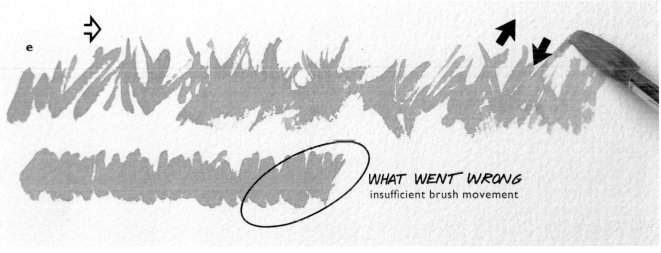

WHAT WENT WRONG
insufficient brush movement

f

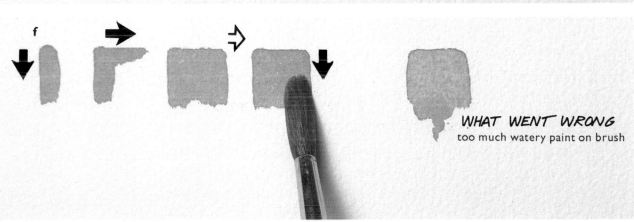

WHAT WENT WRONG
too much watery paint on brush

cannot master them all, improvise with some of your own strokes and you will probably paint just as well. For most of your watercolour brushwork, use the side of the little finger of your brush hand to rest on the paper as you work. This gives you far better control of your brush.

Fig. 27 Using your No. 6 sable brush

g This is the same stroke as **a**, but it is painted with a No. 6 brush. It is a general-purpose stroke and both versions are therefore very important. Use this brush to practise **b** as well. It is important to learn how to vary the pressure of your brush as you move it across the paper. Try this stroke again, but this time start with more pressure and as the stroke progresses, gradually lift the brush off the paper

h Vertical strokes play an important part in paintings, so they must become second nature to you. Note: if you are painting a line up to about 5 cm (2 in) long, vertical or horizontal, move only your fingers; for longer lines you must move your whole arm, otherwise the line will start to curve

i Load the brush and paint a continuous line, at the same time varying the pressure. Make sure you have enough paint on your brush to finish the whole stroke

j This stroke is similar to **e**, except that the brush is moved from right to left and left to right. Push down on the ferrule end of the hairs and let them splay out as you move the brush backwards and forwards. You will get a natural dry-brush effect

k This looks like a doodle but in fact it is one of the most important strokes of all. I use it to fill irregular areas and move on to other areas, filling them all with colour. When you have mastered this stroke, you will feel very much at home with your brush. Mix plenty of paint – the secret is to keep it watery

l Practise these strokes (moving only your fingers), then repeat them, this time making all the strokes longer (moving your whole arm). This exercise will help you to use your brush effectively for small work

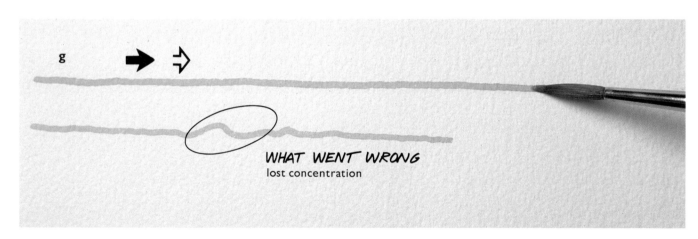

g

WHAT WENT WRONG
lost concentration

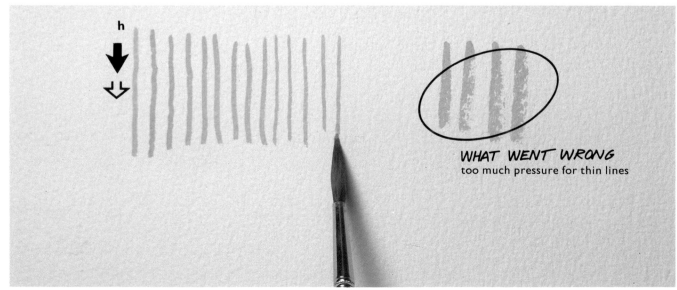

h

WHAT WENT WRONG
too much pressure for thin lines

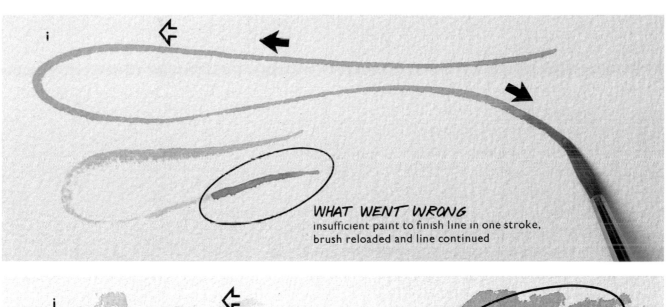

i

WHAT WENT WRONG
insufficient paint to finish line in one stroke,
brush reloaded and line continued

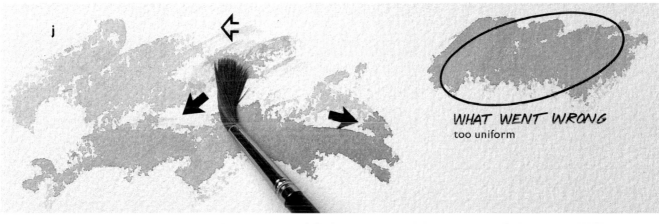

j

WHAT WENT WRONG
too uniform

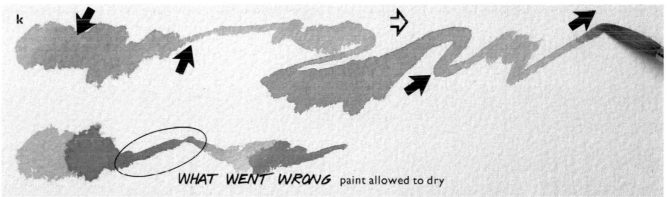

k

WHAT WENT WRONG paint allowed to dry

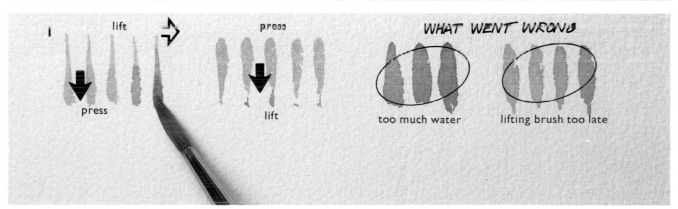

l

lift

press

press

lift

WHAT WENT WRONG

too much water

lifting brush too late

BRUSH CONTROL

If you have worked hard at laying down washes, mixing colours and learning brush strokes, you are now ready to put all that together to paint shapes. When you are happy with that, you will have achieved your first major breakthrough in watercolour painting.

You should now be familiar with your medium, watercolour, and feel happy with its peculiarities, including its unasked-for happy wanderings over the paper! You will also have discovered a paper that suits you. Your brush will feel almost as familiar in your hand as a pen or pencil. From now onwards, but still at a controlled pace, you will be learning how to create paintings, because you now have the means to do it – the knowledge of the medium and the tools that help you to achieve it.

Sorry – back to reality – you have to finish this lesson first!

Look around you and find something simple to copy. I have used a table fork (**fig. 28**). I suggest you do the same, and then find your own objects to try afterwards. Don't worry if the drawing isn't very good; all you want is a shape to work with.

Now have a go at the exercises on the opposite page. First paint the outline of the square (**fig. 29a**), starting with the top line, then the two sides, and finally the bottom. While this is still wet, fill in the square with a wash. On the right (**fig. 30a**), the outline was dry before the inside was filled in and this has given an edge to the box. This is wrong. When you fill in the box the outline must be wet.

Now paint the box again (**b**) and paint up to it, inside and outside, but leave a white (paper) line around it. On the right, the outer wash accidentally touched the wet paint of the inner square and they ran together, taking away the white line. In a painting this is not serious, but if the inner square had been a different colour, then the result would not have been so acceptable because the two colours would have mixed together.

Now draw a simple shape like my houses, **c**. This is a little more difficult than the square. Mix a wash and paint up to the pencil lines as I have done. Don't outline the houses with paint, but work up to the pencil lines with plenty of watery paint, filling in the background in one area; then take the brush on to another edge, filling in that area, and so on. The paint must be very liquid and not allowed to dry while you are working. In **fig. 30c**, the dark area at the bottom between the houses happened because I let too much paint rest there, and it dried. The pigment had run to the bottom and stayed there, hence the darker area. Where you get a reservoir of paint, bring it away with the brush to another area.

The three examples of what went wrong can also be used to enhance watercolours. In the correct place they can be very useful. But these exercises are intended to teach you how to control your brush and the paint. Once you have achieved this, it's up to you what you do in order to create your own type of painting in your own style.

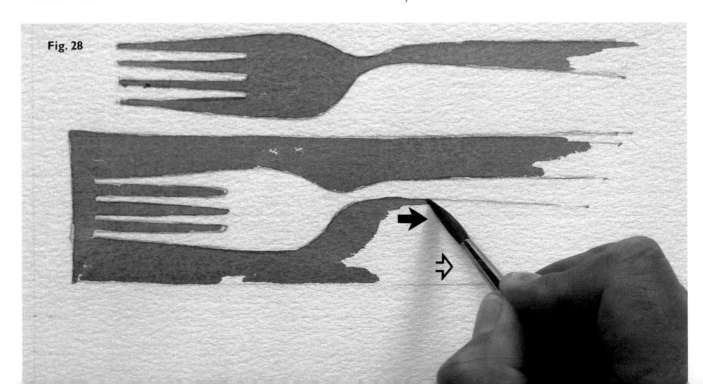

Fig. 28

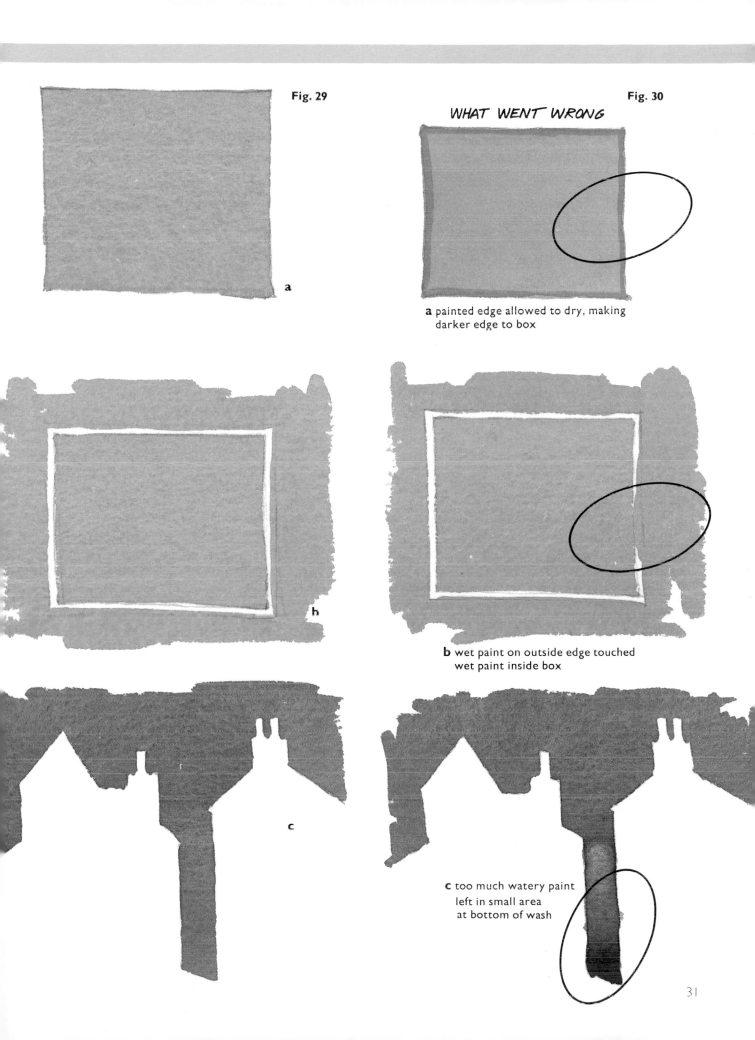

Fig. 29

Fig. 30

WHAT WENT WRONG

a painted edge allowed to dry, making
darker edge to box

b wet paint on outside edge touched
wet paint inside box

c too much watery paint
left in small area
at bottom of wash

a

h

c

FORM AND SHAPE

Up to now all your washes have represented a flat area of colour. Just look around you now, wherever you are, and you will see that every object is three-dimensional. To represent nature, we must understand how to paint objects this way. There is no mystery; it is simply light and shade that makes the form of painted objects.

When I was a small boy at school, one of our jokes was to show someone a blank piece of white paper and ask them what it was. The answer was, 'A white cat in a snow-storm'. If I painted a white box on a white background, the same joke would apply. In **fig. 31** the first box, **a**, can be 'seen' only because I drew pencil outlines. There is no form, it is in silhouette. For **b**, I 'turned the light on' (this can be the sun or artificial light) and the box started to take shape. All I did was to put on a wash, using a tone of white. I mixed French Ultramarine, a little Crimson Alizarin and a touch of Yellow Ochre. Finally, in **c**, when the first wash was

dry, I painted over the right-hand side of the box, using the same colour mix.

Now you can understand why I wanted you to practise your washes. By applying only two washes you can give an object form. And look how simple it is to make the folded card, **fig. 31d** and **e**, look three-dimensional, just by applying a darker wash in the correct place. Objects can be seen because light falls on parts of them, forming shadows on other parts. Light against dark – dark against light. If you have a table or desk lamp handy, move it around and you will appreciate how some objects can be seen more easily when you change the position of the light source.

In **fig. 32** I have taken the box a stage further: I have put a further wash over the background of box **f**. This makes the top of the box more obvious and also gives it more brightness, because it is the only area of white paper left unpainted. But notice what else happens when all the background is painted the same colour

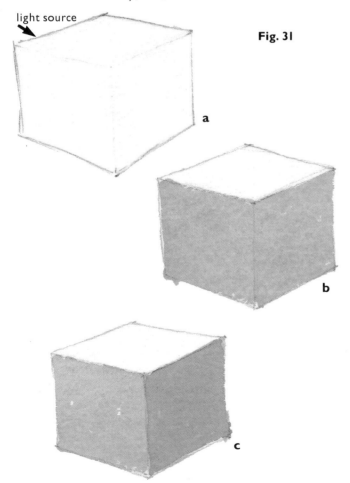

light source

Fig. 31

a

b

c

d

e

Fig. 32

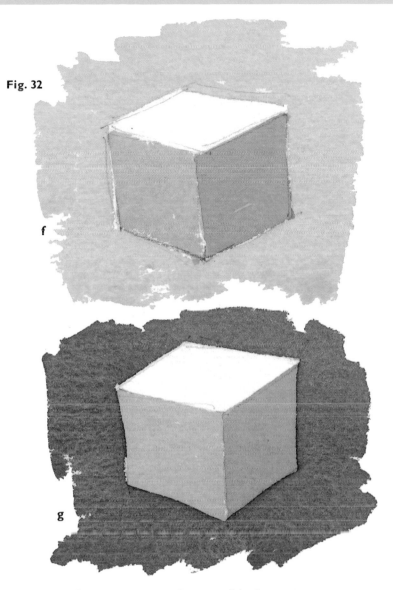

f

g

Fig. 33

light source

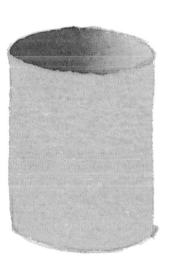

a

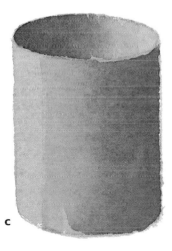

c

and tone. Where it is against the top of the box it is dark against light, while where it is against the right-hand side of the box it is light against dark. In **g**, where I have painted a dark background (darker than the darkest side of the box), wherever the background is against the box it is dark against light. This counterchange of tones, light against dark, dark against light, creates the forms and shapes in a painting.

Look at **fig. 33** where I have painted a hollow tube. After painting the silhouette in **a** I applied only two more washes, yet we have the illusion of a hollow tube. To get the graded wash to work sideways is far more difficult than doing it from top to bottom (page 21). But this has to be mastered.

Find some objects and look at them – carefully – for light and shade, analyse their light and dark areas, then practise painting them.

You will find this lesson most exciting because you are creating the illusion of a three-dimensional object on a flat piece of paper.

ALWYN CRAWSHAW

Part Two
SIMPLE EXERCISES

EXERCISES USING THREE COLOURS

This is where you really start to paint, portraying real objects. But before you start to find things to paint, copy my work on pages 36–40: you will then find it much easier to paint from life in Lesson 9.

I am allowing you to use only the three primary colours: red, yellow and blue. This is one of the best ways to learn how to mix your colours and one of the basic colour lessons of my painting courses. You have to think how to mix your colours. If you want a brown, you have to work out which and what proportion of your three colours you need: you learn how to create the particular colours you want. If you used a ready-made brown you wouldn't learn how to mix that colour. So it is important that you start by using only the three primary colours. I know from experience that you will find it easier than you think. Working on these exercises will give you a tremendous feeling of satisfaction.

I have purposely picked simple-to-draw subjects. If your drawing looks a bit different to mine, it doesn't matter. The objects I have chosen allow for them not to be drawn very accurately, but still look correct. Take the first one, the cherries (**fig. 34**). If you draw your cherries a little more round, or more oval, than mine, it doesn't matter, because they will still look like

cherries. The same applies to the stalks. If they curve or are at a different angle to mine, it will make no difference to the result. There's a very good reason for my choice: your first 'real' painting must be a success. This will give you confidence to go on to the next, and your confidence will continue to grow. You will relax and your painting will improve very quickly.

Try the cherries first. After that, if one of the subjects in **figs. 35–8** on pages 37–40 inspires you more than the others, then paint that one next.

When you have practised these exercises, find your own – simple – objects and paint them from real life.

Fig. 34 Try this exercise first. Mix your colours from the three primary colours – red, yellow and blue – and don't worry if your shapes are not exactly the same as mine

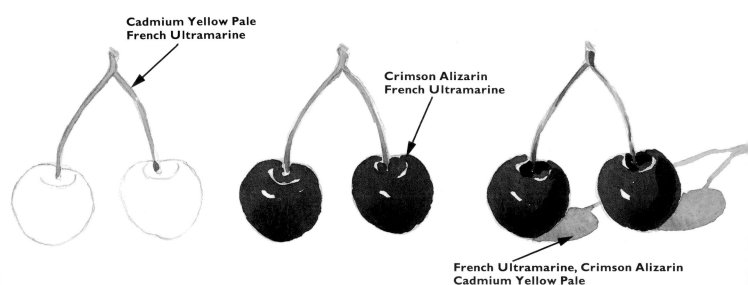

Cadmium Yellow Pale
French Ultramarine

Crimson Alizarin
French Ultramarine

French Ultramarine, Crimson Alizarin
Cadmium Yellow Pale

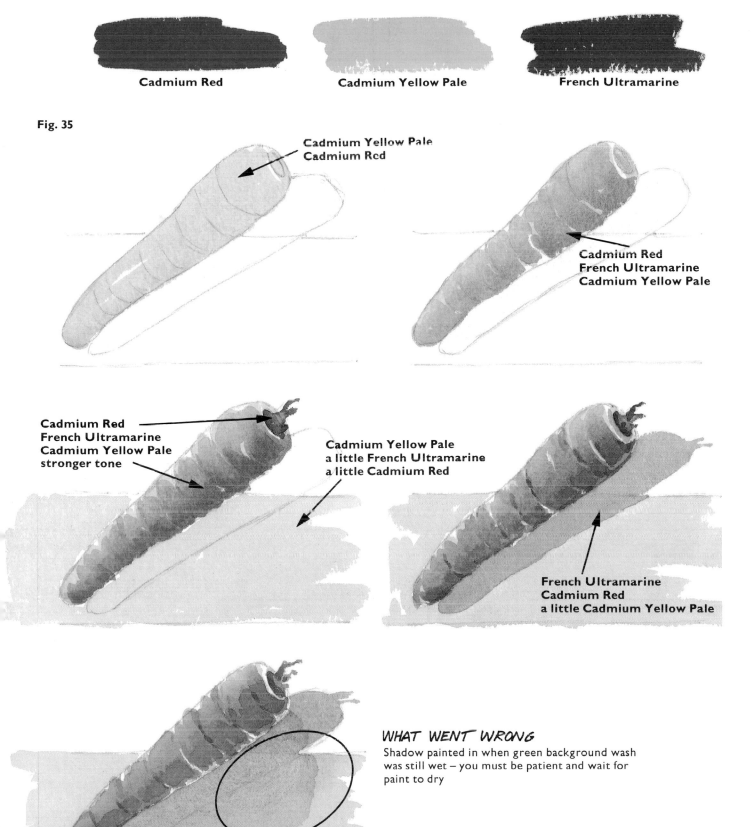

Cadmium Red Cadmium Yellow Pale French Ultramarine

Fig. 35

Cadmium Yellow Pale
Cadmium Red

Cadmium Red
French Ultramarine
Cadmium Yellow Pale

Cadmium Red
French Ultramarine
Cadmium Yellow Pale
stronger tone

Cadmium Yellow Pale
a little French Ultramarine
a little Cadmium Red

French Ultramarine
Cadmium Red
a little Cadmium Yellow Pale

WHAT WENT WRONG
Shadow painted in when green background wash
was still wet – you must be patient and wait for
paint to dry

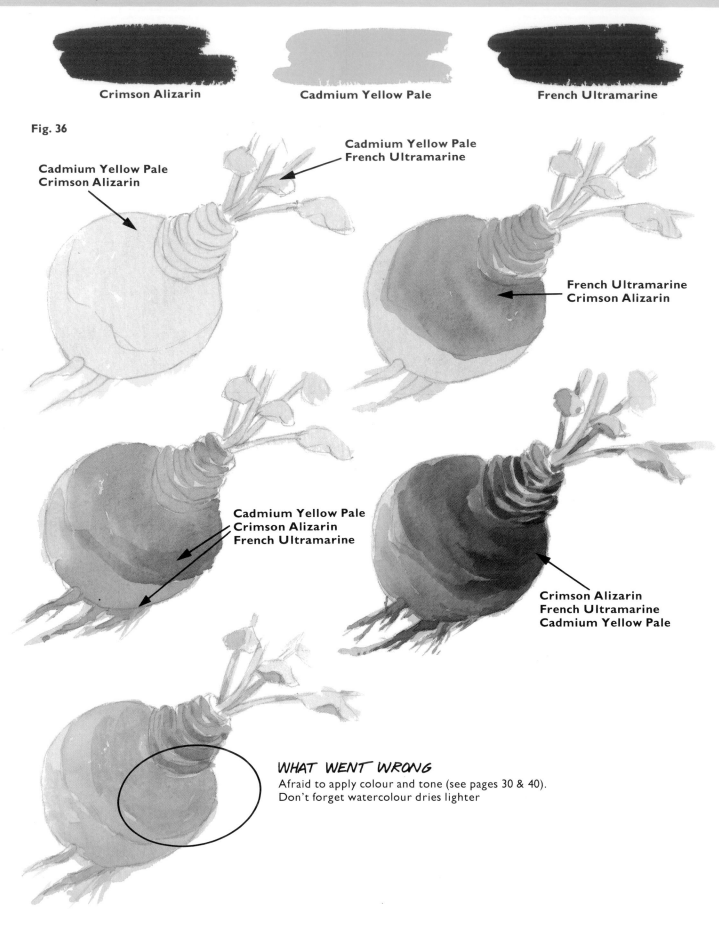

Crimson Alizarin **Cadmium Yellow Pale** **French Ultramarine**

Fig. 36

Cadmium Yellow Pale
French Ultramarine

Cadmium Yellow Pale
Crimson Alizarin

French Ultramarine
Crimson Alizarin

Cadmium Yellow Pale
Crimson Alizarin
French Ultramarine

Crimson Alizarin
French Ultramarine
Cadmium Yellow Pale

WHAT WENT WRONG
Afraid to apply colour and tone (see pages 30 & 40).
Don't forget watercolour dries lighter

Crimson Alizarin **Yellow Ochre** **French Ultramarine**

Fig. 37

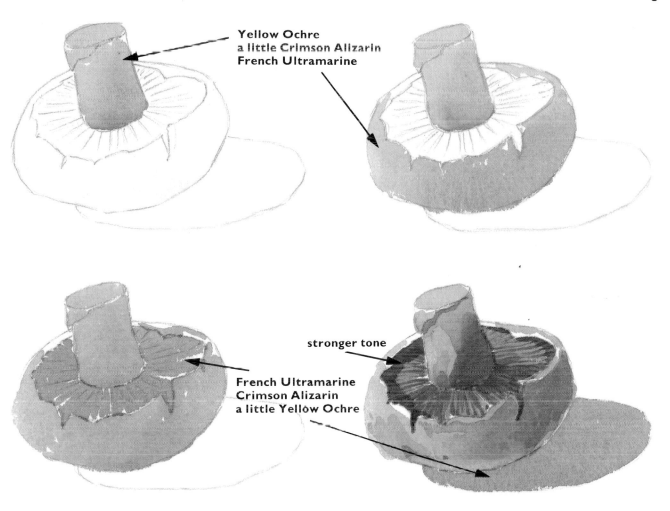

Yellow Ochre
a little Crimson Alizarin
French Ultramarine

stronger tone

French Ultramarine
Crimson Alizarin
a little Yellow Ochre

WHAT WENT WRONG

Yellow skin of mushroom was not left
to dry before mauve inside was
painted. The two colours merged, making it
impossible to get a clean edge as I did in the 3rd stage.
To get a crisp clean line of colour against another, the
first colour must be **dry**

Crimson Alizarin

Cadmium Yellow Pale

French Ultramarine

Fig. 38

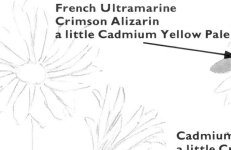

**French Ultramarine
Crimson Alizarin
a little Cadmium Yellow Pale**

**Cadmium Yellow Pale
a little Crimson Alizarin**

**Cadmium Yellow Pale
French Ultramarine**

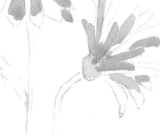

**French Ultramarine
a little Crimson Alizarin
Cadmium Yellow Pale**

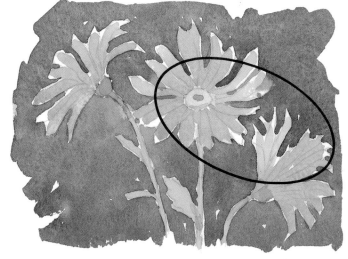

WHAT WENT WRONG

Not enough white paper left unpainted – this makes the flowers look like grey ones. In the 4th stage (above) the grey gives the illusion of the petals being in sunlight and shadow

A SIMPLE STILL-LIFE EXERCISE

In Lesson 8 you painted single objects; now you are ready to paint several objects together. The exercises in Lesson 8 also come under the heading 'still life', so I will explain more about it.

First, let me say that working from still life is one of the best ways to learn to paint, because you can control the subject and working conditions. Still life means that the object or objects to be painted are inanimate and therefore do not move. Traditionally, still life is always done indoors, so you are in control of the light source, be it a table light or angle-poise lamp. Because you set the subject up in position, you are also in control of your viewing and seating arrangements. Because the light on your subject will not change as you work, you paint in perfect lighting conditions, whereas outdoors you have to work to the sun's rules.

If we analyse this, it means that you can find your own subject, light it in such a way as to provide the best visual approach to the subject, make yourself comfortable to work, start painting when you want to (not being at the mercy of adverse weather conditions), finish when you want to and, above all, look at your subject at any time, any day, without its having changed, and, of course, come back and carry on with your painting at any time. You are in complete control. This must make sense as a good way of learning to paint.

The best way to set up a still-life subject is to arrange it all on a board. This gives it manoeuvrability. If you set it up on a table, the family might want to use the table before you have finished the painting. You can fasten some of the objects down with Blu-tac, which makes moving the group on the board safer; also, you can change your view-point without changing your working position simply by rotating the board. By this method, and also by moving your lamp, you can get the best effects possible. The creation of a still-life group can be very absorbing, as you are using your creative skills. But don't forget that the object is to paint it. Don't spend so long creating the scene that there's no time to paint it, as I have done in the past.

Although still-life objects will stay in position until the end of the painting, remember that fruit, fish, and in particular flowers, will change or move during a painting (depending on how long it takes you to finish). Nothing's perfect, is it?

Now try the exercise in **fig. 43**. Draw the flower with a 2B pencil (**Fig. 40** Stage 1). Mix Crimson

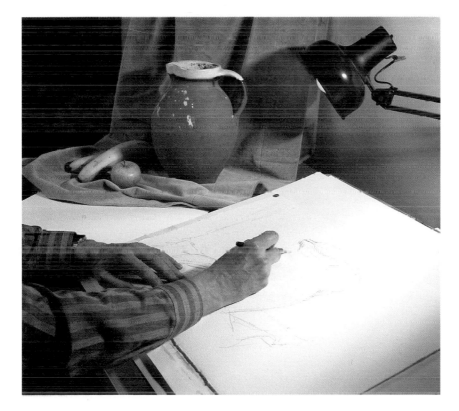

Fig. 39 Set up your still-life subject on a board so that it can be easily moved if you need to use the table for anything else before your painting is finished. By rotating the board and moving your lamp you can achieve many different effects

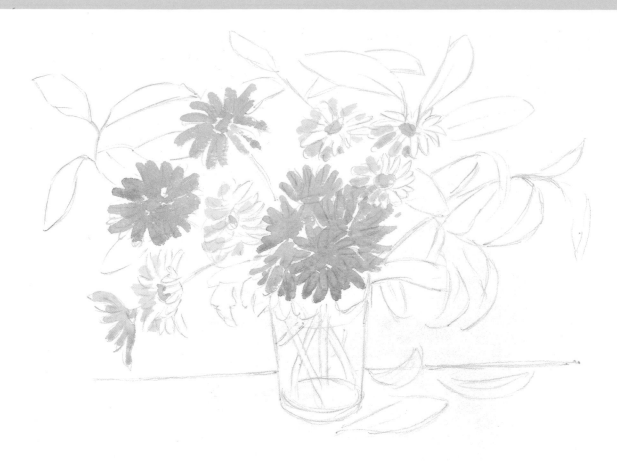

Fig. 40 Stage I

Fig. 42 (opposite, above) Stage 2

Fig. 43 (opposite, below) Finished stage. Bockingford 200 lb,
30 × 23 cm (12 × 9 in)

Alizarin and Cadmium Yellow Pale for the pink
blooms, Cadmium Yellow Pale and Cadmium Red for
the orange ones, and for those white flowers that you
are going to paint use a mix of French Ultramarine,
Crimson Alizarin and a touch of Yellow Ochre. Then
paint in all the blooms very freely with your No. 6
sable brush.

In Stage 2 (**fig. 42**), when the paint is dry and using
the same brush and the colour you used for the white
flowers, work the background freely around the leaves.
Paint the jug with the same colour. When the wash is
dry, with a darker mix of the same colour, paint in the
stalks of the flowers in the jug.

In the finished stage (**fig. 43**), mix Cadmium Yellow
Pale, Hooker's Green No. 1 and Crimson Alizarin to
paint the leaves, changing the colours and tones as you
work. With a darker mix of the flower colours, paint
shadows on them to give form.

Finally, add some dark accents where your own
painting needs them to help show form, and paint the
shadow on the table top.

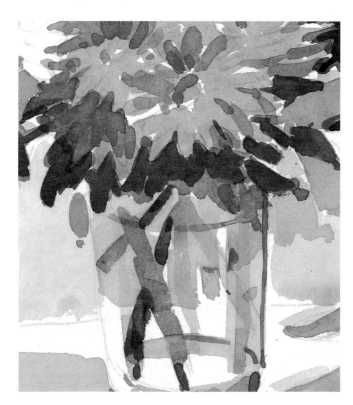

Fig. 41 Detail of finished stage, **fig. 43**

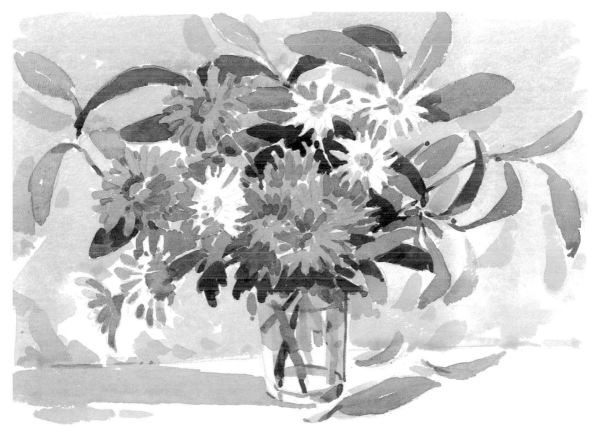

LESSON 10

TONAL VALUES

This lesson is a natural continuation of Lesson 7, but I have left it until now because some of the problems you will have found, working from your own still life subjects, can be resolved in this lesson.

In Lesson 7 I explained that we paint dark against light and light against dark to give objects form and shape. But if we are looking at a real-life object or scene, it can be difficult to see what is dark and what is light. Or, more importantly, which is the darkest or lightest area in relation to other areas of the same scene. The colour of objects can distort this for us. For instance, you have probably grown up believing that yellow is a very light colour, but if yellow is in an unlit or shadow area, then it can look very dark. Similarly, in a situation where the light is cast on it, a dark blue can look very light. This means that colour can confuse us when we are trying to 'see' the relative dark and light areas of a scene. If we do not get the tonal values (darks and lights) correct in a painting, it will look wrong; it will appear lacking in form.

The way to overcome the problem of tonal values is to screw up your eyes when you look at the scene or object. This has the effect of taking away some of the middle tones, so you see only the real darks and lights. Some objects will merge together, because tonally they are the same, although they may be different colours. Look at an apple and screw up your eyes. I am sure you will be surprised how dark the area of the apple is where it is resting on the table. In **fig. 44** I have painted one, but I have exaggerated the darks and lights to emphasize the point. The bottom apple that went wrong has had only a little more working than that at the top of the page. I have seen students stop at this second stage for two reasons. First, they are frightened to put more dark paint on the apple because 'it might spoil it'. Second, they have not been taught how to observe and look at the subject with half-closed eyes. Had they done so, they would have 'observed' the dark areas that make the apple look round and give it form.

It is important to learn to observe objects and scenes by screwing up your eyes to separate the tonal values and you should practise it until it becomes second nature. To begin with, the best way to practise seeing tonal values is to work in one colour only. Set up a simple still life, then sit and look at it with half-closed eyes. You will be able to pick out the dark and light tones. Then paint it in one colour. Let the full strength of the colour be the darkest tone; let white paper left

unpainted be the lightest. You will find this strange at first. Try not to 'see' colour but just to see the subject in tonal values and paint accordingly, checking as you paint one tone against another. Say to yourself as you work, 'Is that area as dark as the area on the left?' or, 'That's surprising – this shape is the same tone as that one'. Well, paint it like that; it will look correct when the painting is finished.

Look at the cup I have painted in **fig. 45**. In the first stage I used one colour wash. The pencil lines that are left showing help to keep the form of the cup against the white background (dark against light). But I wanted the cup against a background tone, so in the second stage I worked the background on the left in a darker tone to show the light side of the cup, and on the right-hand side I watered down the colour to finish very pale – in fact, I left unpainted white paper. This made the background light against the dark side of the cup. I darkened the inside of the handle to help to show it up against the background tone. I left the rim of the cup white paper, to show the shape of the top of the cup.

Now the one at the bottom is interesting. The tonal values are too similar. The left side of the cup is light against light ('white cat in a snow-storm'); the right side is dark against dark. Therefore I have not achieved what I set out to do. However, the result has created a cup that loses its shape in places and regains it in others. For example, the rim of the cup is white against the dark background, but on the right side it loses its white edge as it merges into the white background. This is called 'lost and found'. It leaves parts of a painting to your imagination and gives the painting a 'free' look. Only experience will tell you when to let this happen. So let that come to you naturally. In the meantime, work at getting the correct tonal values into your paintings to give objects their correct form.

Do take time to practise this lesson – it will greatly improve your painting.

(opposite, left and right) **Figs. 44 and 45** Exercises in adding tonal strength

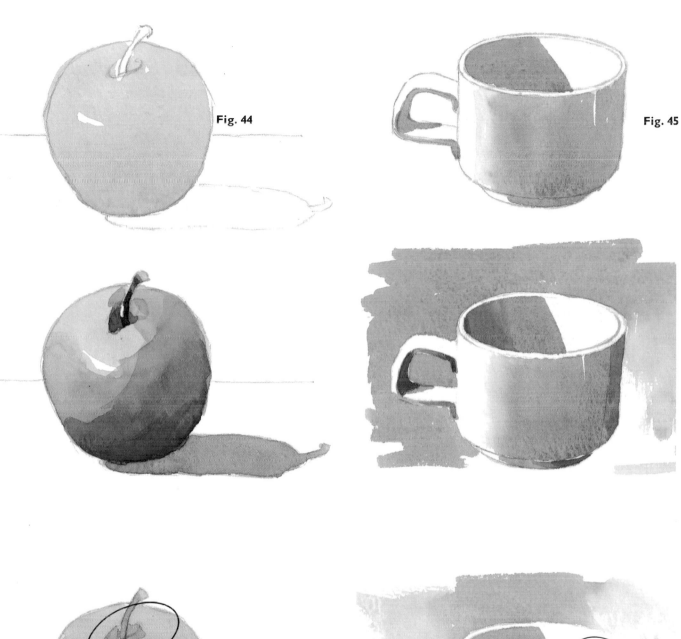

Fig. 44

Fig. 45

WHAT WENT WRONG
Not enough dark paint worked into the apple. It needs the dark areas to show form – the roundness of the apple

WHAT WENT WRONG
The cup is 'lost' in places because its form and shape have not been worked out. But when you have gained experience, this way of painting 'lost and found' can be very interesting

Part Three
DRAWING

DRAWING WITH A PENCIL

It may seem a little odd that I haven't put this lesson in before now: after all, you have been using a pencil in your painting exercises. The reason is that I didn't want to stop the natural sequence of the early painting lessons. But I think it is time that we looked a little closer at the drawing side of painting. To be able to draw well gives you an added bonus and enables you to paint more complicated subjects. So improving your drawing can only add to your painting ability. But as in all these lessons, you have to practise. The great thing about drawing is that you can pick up a pencil almost anywhere and draw something – so there's no excuse!

The pencil is, of course, the most important piece of equipment for drawing and, naturally, we all take it for granted. But now let's look at the pencil from an artist's point of view. A good artist's pencil has 13 degrees of lead. For everyday use, the one most commonly used is an HB. This is in the middle of the hardness scale. On the B side, the leads become softer and darker as they reach the top of the scale, i.e. B, 2B, 3B, 4B, 5B and 6B (the softest); and on the H side the leads become harder and lighter, i.e. H, 2H, 3H, 4H, 5H and 6H (the hardest). Don't worry about all those different grades, you need only an HB and 2B to draw for watercolour painting, but if you want to experiment with other grades, then do so.

You must have your pencils sharpened correctly. Look at **fig. 46**. Your pencil should never look like **a** – you would get as much character and response out of the lead as you would trying to play the piano with all the black notes missing! Your pencil should have a long tapering point, **b**, so that you can use either the point or the side of the lead for shading. When you sharpen your pencil, **c**, use a sharp knife and cut off controlled positive 'slices', making a long gradual taper to the lead.

On the opposite page I have shown you the three most important ways of holding your pencil for drawing. **Fig. 47** shows what I call the 'short' drawing position, which is just like the way you hold your pen for writing. It gives you the most control over your drawing. But remember Lesson 5 (page 28), when you were drawing short vertical or horizontal lines with your brush: move only your fingers for short lines, your whole arm for long lines.

For a more free and flowing movement, in particular for working over a large area (**fig. 48**) the 'long' drawing postion will give you more versatility.

Fig. 49 shows the 'flat' drawing position. This is a totally different way of holding your pencil, which is almost flat on the paper, held off by your thumb and finger. By this method you can work fast, free, broad strokes, using the long edge of the lead to give large shaded areas. Usually, in watercolour painting, you would use shading only for a pencil-and-wash painting (see page 59).

There are infinite variations on the three positions I have described. Using these as a base, learn to use a pencil all over again. As you did with your brush, doodle with a pencil.

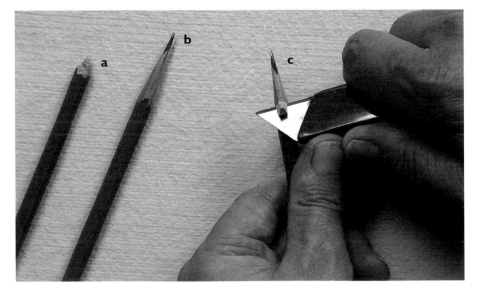

Fig. 46 (left) The wrong and right way to sharpen your pencil

(opposite, top to bottom)
Fig. 47 The 'short' drawing position gives you most control
Fig. 48 The 'long' drawing position allows versatility over a large area
Fig. 49 By using the 'flat' drawing position you can work large shaded areas with fast, free, broad strokes with the long edge of the lead

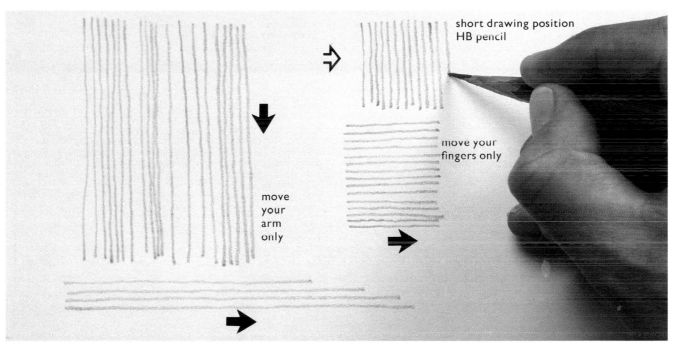

move your arm only

short drawing position
HB pencil

move your fingers only

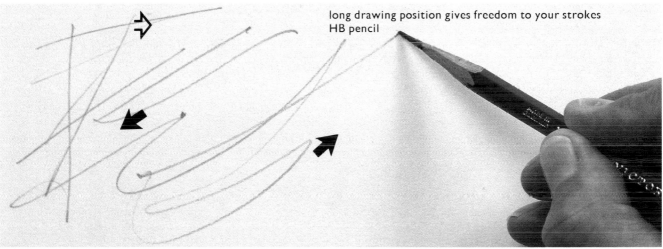

long drawing position gives freedom to your strokes
HB pencil

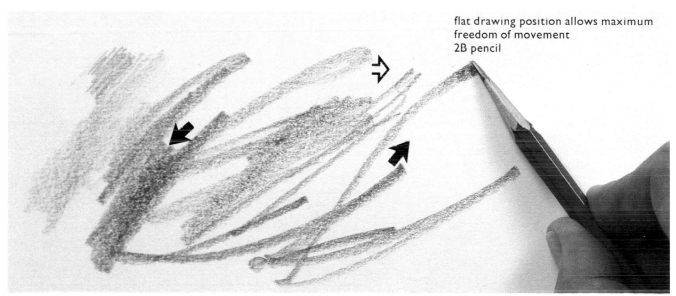

flat drawing position allows maximum
freedom of movement
2B pencil

PERSPECTIVE

I wonder whether you are one of my readers who would like to pass over this lesson as though it didn't exist? Many students fight shy of perspective, simply because it seems more like arithmetic or geometry than painting. However, by learning just a few fundamental laws of perspective you will be able to draw and paint more easily.

Let's begin with the eye level. If you look out to sea, the horizon will always be at your eye level, even when you climb a cliff or lie flat on the beach. Check this by holding a pencil horizontally at arm's length and looking past the pencil to the horizon: the pencil will be aligned with it. So the horizon is the eye level (EL). If you are in a room, naturally, there is no horizon but you still have an eye level. Hold your pencil at arm's length, and look past the pencil to the opposite wall: your eye level is at the spot you are looking at.

If two parallel lines were marked out on the ground and extended to the horizon, they would come together at what is called the vanishing point (VP). This is why railway lines appear to approach each other and finally meet in the distance – they have met at the vanishing point.

Look at **fig. 50a**. I drew a flat square on paper. Then I

drew a line above to represent the eye level. Then above and to the left of the eye level I made a mark, the vanishing point. With a ruler I drew a line from each of the four corners of the square, all converging at the vanishing point. This gave me the two sides, the bottom and the top of the box. To create the other end of the box, I drew a square parallel with the front of the box and kept it within the vanishing point guidelines. The result is a transparent box in perspective. We are looking down on the box because the eye level is above it, but in **b** we are looking up at the box, because the eye level is below it. You see the underneath of everything above your eye level and the top of anything below it.

Try this simple experiment which helped me when I was a student at art school. Hold a coin flat in front of your eyes (**c**). All you will see is a straight line. Now move the coin up (holding it flat all the time) and you will see the underneath of it; the shape will be an ellipse (a circle in perspective). Now move it down past your eye level and you will see the top of the coin.

Fig. 50d, shows how to work out a row of houses with windows and doors, **fig. 51**, opposite, shows a street scene drawn after the eye level has been established.

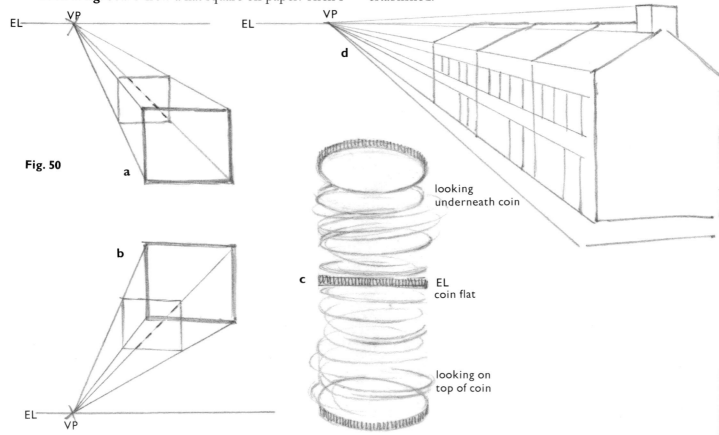

Fig. 50

a

b

c

d

looking underneath coin

EL
coin flat

looking on top of coin

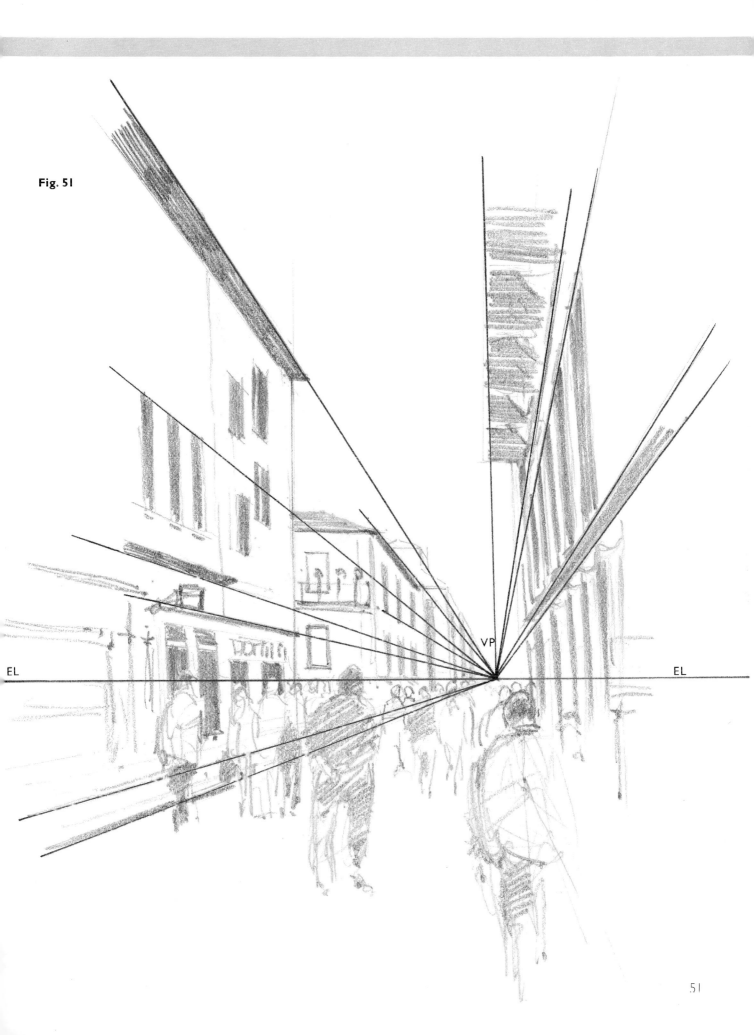

Fig. 51

EL

VP

EL

51

MEASURING

Fig. 52 (left) and **53** Vertical and horizontal measuring

This lesson is one of the most important in the course. It teaches you how accurately to draw objects from life in their relative sizes and positions. Although to start with you may find measuring tedious, or perhaps feel it is a little mechanical, you must persevere: it is a very important skill to acquire. Measuring is as much part of drawing as putting pencil to paper.

No doubt you have seen cartoons of an artist looking at his subject, holding his arm out with his thumb up. He is measuring his subject. The only difference in real life is that an artist uses a pencil for measuring. Hold your pencil at arm's length, vertically for vertical measuring and horizontally for horizontal measuring, with your thumb along the near edge as your measuring marker (**figs. 52** and **53**). Unless you keep your arm at the same distance from your eye while measuring objects in the same composition, the comparative measurements will not be in proportion, so hold your arm straight – it is then easy to find the same position each time.

When measuring, you simply need to establish the correct proportions of the objects; so let me take you through an example. Suppose the sketch in **fig. 54a** is a real row of houses. Draw a part of your sketch, say house no. 3, on your paper as in **b**. You now need to get houses nos. 1 to 7 on your sketch as they appear in reality.

Hold up your pencil to measure house no. 3 and, as you move your hand along, measure how many widths of house no. 3 will divide into the length of the seven houses (nine). Check your sketch, **b**, and using your pencil as a scale, measure whether the width of the house no. 3 you have drawn can be drawn along

your paper nine times. In **b** it can be drawn only about five times. So draw a smaller house on the same sketch, **c**, and by simple trial and error you will come to the size of house that will be in proportion to the rest of your picture.

Now hold up the pencil to the real houses to measure how many widths of house no. 3 can be divided into houses nos. 1 and 2. You will find that they are all the same size. Therefore, on your paper, you can measure three houses from left to right, the third being no. 3, which is your key measure, **d**. Looking up at your subject again measure how many widths of house no. 3 can be divided into house no. 4 (two). On your sketch, using your pencil as a ruler and your thumb as a marker (use the same procedure as for measuring your real subject) measure a distance twice as long as, and to the right of, house no. 3. You thus have the correct measurement for house no. 4. Carry on in this way until you have drawn your row of houses from 1 to 7 and they will fit your paper exactly, **e**.

Now check the height of the houses. Measure the width of house no. 3 and turn your pencil vertically, with your thumb still in position, and see how many widths of the house will divide into its height. You will find that it fits exactly once, up to the bottom of the eaves. On your sketch, use your no. 3 house measure and mark the height of the houses, as in **f**. Then check the height of the roofs, and so on.

If you take time to do this, you can put as much detail and work into the houses as you want, knowing that your drawing will fit your paper and that it will be proportionally correct.

Look at the photograph in **fig. 55**. My key measure here is the width of Big Ben tower and you can see how, by using just this one measure, I can work over the scene to establish the relative sizes. Naturally, you can have two or three different measures to help build up a complicated picture. For example, to find the depth of the top windows in the dark building on the right of Big Ben, I would measure how many times their depth could be divided into the width of Big Ben tower (key measure), and so on.

Measure your important subjects and draw them in position, then as you draw the rest they should fit into place correctly. When you are measuring don't be too rigid. If an area of your subject measures a key measure and a bit, then draw it on your sketch the size of a key measure and a bit.

Please read through this lesson carefully, several

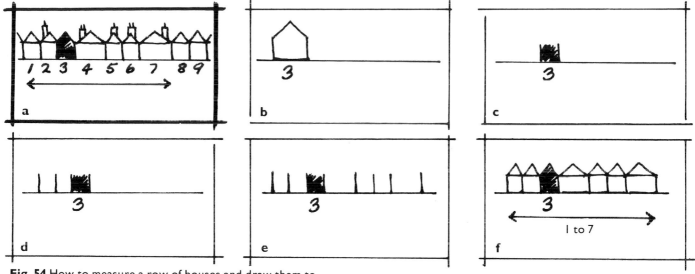

Fig. 54 How to measure a row of houses and draw them to fit your paper in the correct proportion

times if necessary, make sure you understand the method, and then practise it. Try it when you are sitting at home; you will soon get used to it. Frequent practice will train your eye to estimate the size of objects in relation to each other without measuring, and to place them correctly on your paper. This is a very important lesson.

key measure

Fig. 55 From my photograph I took as my key measure the width of Big Ben tower, and from this I was able to establish the relative sizes of all the other subjects in the picture

DRAWING WITH A BRUSH

We have now reached what is really the last lesson on the application of watercolour; after this, we are more concerned with making paintings. You now have the basic knowledge to paint a picture, if you have been practising, but first you need to practise even more with your brush – to draw with it. When you think about it, painting is in fact drawing with a brush. It is impossible to show every brush stroke I have used in these exercises, so I have indicated just the important ones. Don't try to copy my exercises exactly or you will be too tense and you won't obtain good results. Use mine as a guide, then choose your own subjects.

Fig. 56 below I did without drawing in pencil first. I used my No. 6 sable brush and painted straight in. I copied it from a pencil sketch I made of an ostrich at the zoo, to show just how we really do draw with a brush. It was all done with the **k** brush stroke (see pages 26–9), except for the tail feathers, where the stroke turned into a free **h** stroke. I painted it on cartridge paper the same size as reproduced here. Ostriches are comical birds to draw from life, but when feeding they do stand still, within reason!

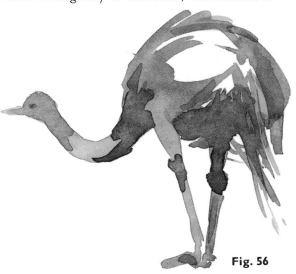

Fig. 56

Draw the exercises in **fig. 57** first with a pencil, then when you are more confident, choose a simple subject to attempt with the brush only. I worked on Whatman 200 lb Not paper for the boats and farm buildings, and cartridge drawing paper for the rest. The originals are about one-and-a-half times larger than reproduced here. I used my No. 6 sable brush for everything except the sky and ploughed field in the farm sketch. I used my Dalon Rigger Series No. 99 No. 2 for the smaller branches on the tree, the rigging on the yacht, the

telegraph poles and the fence.

For the fishing boat in the top exercise, I painted first the green cover, then the hull. When the cover was dry, I painted on another tone to represent the areas in shadow. All this was done with brush stroke **k**, and for the dark line down the stern I used stroke **h**. The two boats to the left were very simply painted. I used **d** for the water, the dry-brush stroke giving it a sparkle. The outline of the yacht is **h**, the figures and reflections **k**.

In the horse exercise, apart from the nose-band, the short piece of harness and detail in the farmer's coat, I used only **k**. This is a very good example of how much this brush stroke is used, and how important it is.

I painted the sky and the trees on the left in the farm exercise with stroke **j**. For all the buildings, walls and roofs I used **k**, but in a controlled way, keeping the buildings crisp and sharp. I painted the field with **a**, working the strokes from the bottom of the paper, travelling in perspective up towards the hedge. I allowed stroke **d** to happen, to create a dry-brush effect in places.

Please don't get too worried if you find some of the brush strokes awkward or difficult. These exercises are to show how areas of paintings are created by the brush. If some of the brush strokes don't suit you, please use your own; they may work better for you. Remember, you are the creator of your paintings. If you find that by hanging from a rope ladder, upside down, you can create masterpieces, then that's the way you should work – I'm glad it's not my method!

Finally, I must now explain what I believe is perhaps the most important rule for creating paintings. Your brush makes the marks and shapes on your paper. The instructions come from your brain. Therefore, if you are painting a cloud, **you must 'think and be' a cloud** while you paint it. If you were thinking about trains or battleships, your brush strokes would not have the soft, feathery look to them that clouds have; they would be heavy and hard, and totally out of character. When you are painting clouds, tell yourself you are a cloud and let your brush be light and feathery, dancing over your paper. Because your brain is thinking about the object, the response in the brush (hand) will be more tuned in to the subject; it will react more quickly and with more feeling. Whatever you paint, you must imagine yourself being that subject. I am sure you will be surprised at the results. Please don't think I am being frivolous. My feet are still firmly on the ground!

Think about it, and practise.

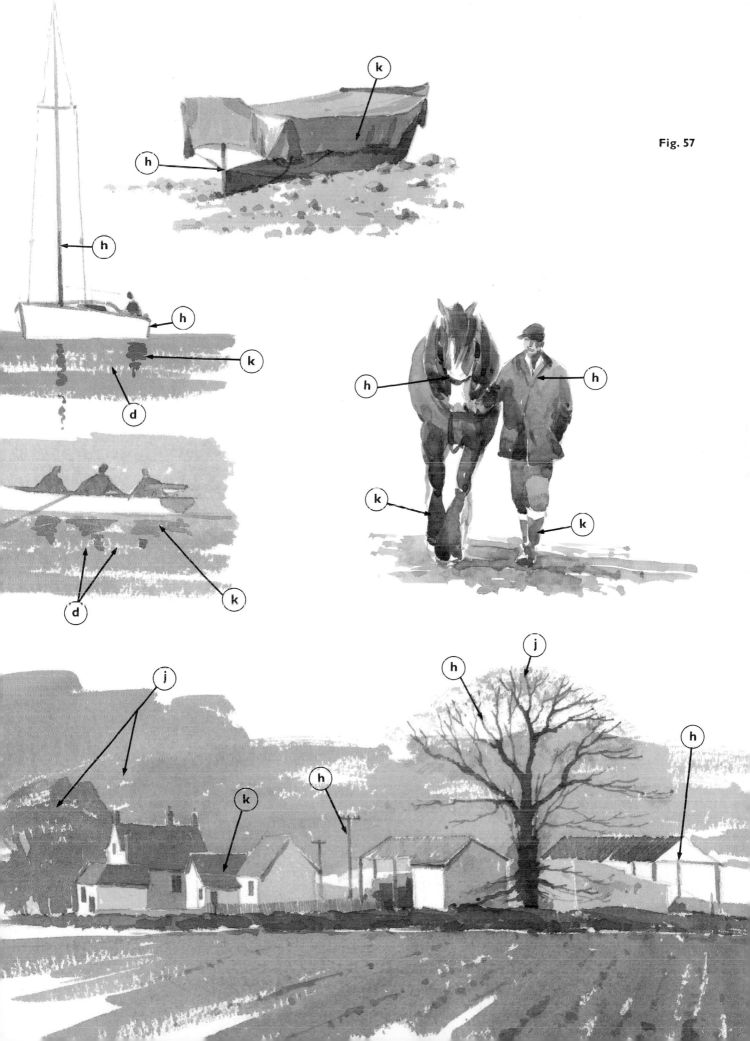

Fig. 57

Part Four
PAINTING TECHNIQUES

FIVE WATERCOLOUR TECHNIQUES

One of the beauties of watercolour is that it is so versatile. Different artists use it in different ways. And because every artist has his or her own style, if six artists were to paint the same subject, using the same technique, each painting would look different. The style of a painting is determined by the artist's own particular way of painting; but the technique is a method of painting that all artists can use. For instance, look at the pencil-and-wash painting (**fig. 60** opposite). A thousand artists could have painted the same scene, in pencil-and-wash, and yet every one would have been different – because of the artist's own natural style. But the technique remains the same. By now, your own style will be developing, and you should let it flourish; it is a natural progression.

On the following pages I have painted Exmouth harbour in five different watercolour techniques, so that you can compare them. Some subjects do not necessarily lend themselves to a particular technique but, on the other hand, some subjects are obvious choices for just one technique. So you must choose your subjects and techniques with care.

Flat wash and graded wash
I regard this technique (**fig. 58**) as the basic, traditional way of using watercolour. Having first thought out the moves very carefully, work up the effect with washes, painting lighter colours first and gradually adding the darker tones. This is how you painted in Lessons 8 and 9.

Fig. 58 (below and on pages 56–7) *Exmouth harbour.* Flat and graded wash. Whatman 200 lb Rough, 56 × 39 cm ($22\frac{1}{2} \times 15\frac{1}{4}$ in)

Fig. 59 (opposite, above) *Exmouth harbour.* Flat, graded and wet-on-wet washes. Whatman 200 lb Rough, 56 × 39 cm ($22\frac{1}{2} \times 15\frac{1}{4}$ in)

Fig. 60 (opposite, below) *Exmouth harbour.* Pencil and wash. Cartridge paper, 41 × 30 cm ($16\frac{1}{4} \times 11\frac{3}{4}$ in)

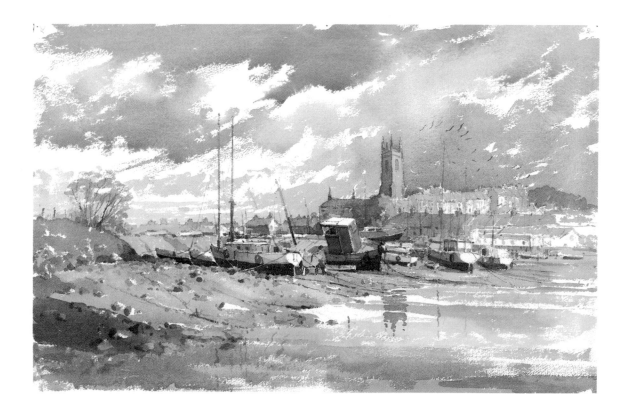

Flat wash, graded wash and wet-on-wet

This technique (**fig. 59**) is really an extension of the previous one, allowing wet paint to run into wet paint. I used it to achieve a late evening effect. First I wet all the paper and painted a wash over it, changing the colours and tones as I progressed, losing all the 'white' paper. I then applied another wash over the whole painting, to give the half-light atmosphere of late evening. I did this before the existing paint was bone dry so that I could merge the second wash into the first. A lot of practice is needed to perfect this technique.

Pencil and wash

Fig. 60, below, shows an example of the pencil and wash technique. You can work either very delicately or strongly and boldly, dependent upon the way you **draw** your picture. The tonal values are created by the pencil (shading) and colour washes applied over the top. Therefore the method of painting is easier than making the tones by mixing your colours, darker and lighter. You will see that I frequently use pencil and wash outdoors. I love it, but usually only up to A4 size. There are examples throughout this book.

Fig. 61 *Exmouth harbour*. Pen and wash. Ivorex board
290 gsm, 51 × 41 cm (20½ × 16 in)

Pen and wash

Pen and wash (**fig. 61**) is a very popular technique and, at some stage, most students have a go. I paint first, then draw over with a pen, but you can work the other way round if you find that suits you better. When you apply the paint you can work wet-on-wet, letting all the colours run together as much as you like, because you will be drawing over the top of them with your pen and this will hold the painting together. I used a 'dip-in-ink' pen with a drawing nib, and black Indian drawing ink (waterproof). You can, of course, use other pens, including felt-tip and fountain pens, but make sure the ink is waterproof, otherwise if you want to add more paint over your ink line, the ink will run.

Body colour

As soon as you add White paint to your watercolours, they lose their transparency. You can therefore paint from light to dark as usual in watercolour, or you can work from dark to light by adding White paint to give your colour body so that you can work light colours over dark ones. Instead of adding White to your watercolours, you can use tubes of body colour paint called Designers' Gouache, which enable you to build up a painting almost like an oil. Some artists work on a dark paper and achieve a very strong bold picture. This technique allows you to put incredible detail into your work, if desired. I worked the painting in **fig. 62** with Designers' Gouache.

Fig. 62 *Exmouth harbour*. Body colour. Cream Ingres paper
160 gsm, 50 × 37 cm (19¾ × 14½ in)

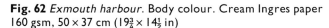

Part Five
WORKING OUTDOORS

ALWYN CRAWSHAW

WORKING OUTDOORS

I don't recommend that you venture outdoors to work until you feel capable of handling watercolour, but by now you should be happy with that, and if you are concerned at all it will be because you are going to paint in public. What a thought! Well, usually some students – the extroverts – are eager to start, but others keep putting it off, simply because they worry about people watching critically while they paint.

But there's no reason to worry. When people stand and look at your work while you're painting, their first thought is usually, 'How lucky **you** are, **not** being afraid to paint out here with all the public around to see you'. Then they will look at the picture. Remember: they don't know (they're not artists) what stage your painting has reached. If it's not finished, they accept the fact that it is a good painting, but unfinished; if it is almost finished but not very good, they don't know you have finished, so again it's good, but unfinished.

If an artist stands behind you, then he or she will probably know whether your painting is good or not,

but because you have a common bond and all artists know the problems of working outdoors, he or she will chat, and perhaps, between you, you will help the painting along. If children come along, their comments are either: 'My sister can paint better than that', or 'Isn't that fantastic? You must be a real artist!' If it's the former, naturally it won't be true, but chat to the children on the understanding that you are second-best. If it's the latter, then take the compliment, chat to the children and bask in the glory. When someone comes to watch you, your fear is all in your mind: most on-lookers will envy you. These comments are the result of my experience in talking to students and on-lookers during my painting career.

I don't mind people watching while I work, otherwise I couldn't teach. In fact, I think the most frustrating situation is when you believe you have painted a masterpiece and no one comes to look at it! That's happened to me on many occasions. So don't be worried about working outdoors. Go ahead and make a definite date, perhaps with a painting friend. And

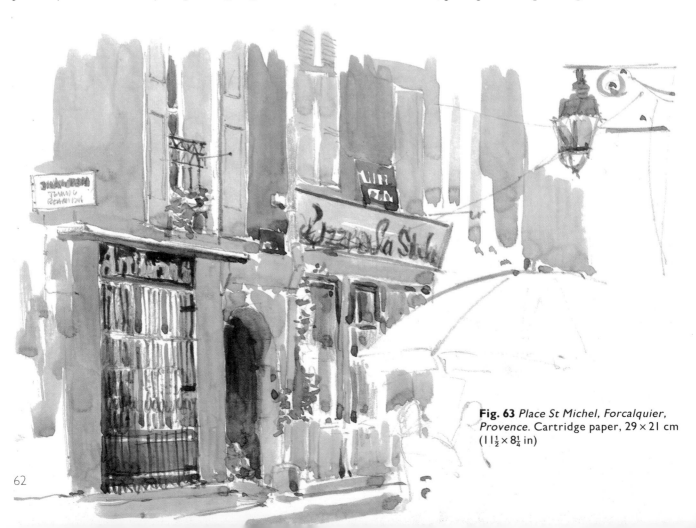

Fig. 63 *Place St Michel, Forcalquier, Provence*. Cartridge paper, 29 × 21 cm (11½ × 8¼ in)

don't forget: you may not even see anyone!

I painted the picture below (**fig. 63**) as a demonstration for some students in Provence. It was the buildings that inspired me, as I sat at a table outside a café. I left until last the painting of the sun umbrella, table and people, because I was worried that it would all be too dominant and detract from the delicate shapes and colours of the buildings. As you can see, I finally decided not to paint them. I think that helps to give the painting a more relaxed, painted-on-the-spot look. During the same course, **fig. 64**, we took the students to see the mountain that Cézanne could see from his window and painted many times – Mte Sainte Victoire – and I painted **fig. 65** as a demonstration. I did this as a half-hour exercise, but more about that in Lesson 18. Notice how I gave the impression of sunlight on the mountain by leaving the paper unpainted.

Now let us consider some practical points concerning painting outdoors:

1. Warmth
2. Equipment
3. Spot
4. Comfort
5. Observation

The easy way to remember this list is by the mnemonic WESCO. The rules are simple and mostly common sense, but they form the basis for working outdoors. If you follow these rules you will be in control, and you could paint a masterpiece. Let's have a look at them.

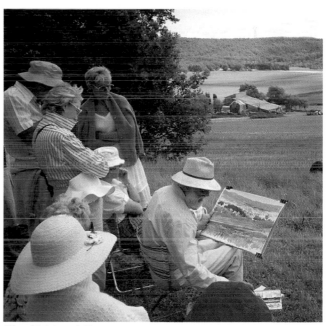

Fig. 64 (above) Demonstrating a watercolour technique to students on a painting course

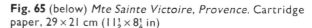

Fig. 65 (below) *Mte Sainte Victoire, Provence.* Cartridge paper, 29 × 21 cm (11½ × 8¼ in)

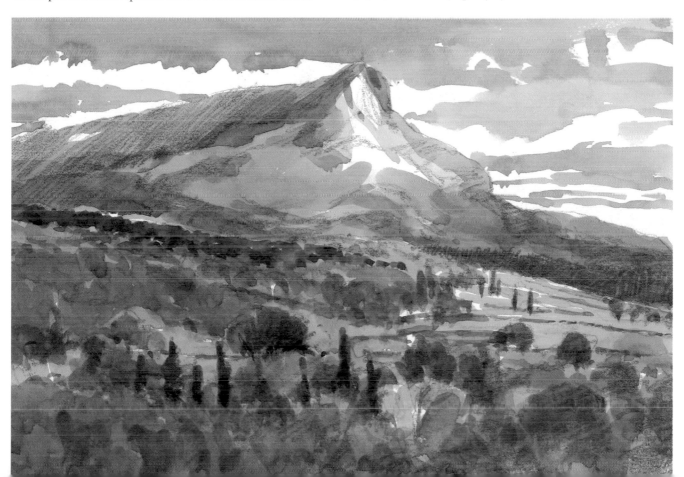

Warmth In cold weather, if you don't take extra clothing with you, you may be forced to abandon your painting trip. Just imagine sitting in a warm room writing letters – then think of doing the same thing outside, on a cold misty river bank. You wouldn't dream of it. So, if you want to paint on a river bank, you have to leave the warmth and comfort of your home to brave the elements. In summer the conditions are ideal, but some of the best moods of nature are to be found at other times of the year when the weather can be very cold. So always take enough clothing to keep warm. If you are unsure, take extra.

Equipment Items of equipment are covered in Lesson 1. The most important point to remember is that you must not take so much that you have difficulty walking to your painting spot (which could be half a mile from where you park your car); or, if you were walking from home, so that it becomes hard work before you have got very far. I have seen students take up to a couple of hours to walk to a spot with their equipment, unpack it, sort it out, set it up and then, for the first time, look at their subject – and they were only a hundred metres from their car! Frustration and tiredness set in, and going through the same routine again when it was time to leave didn't give much time for their painting.

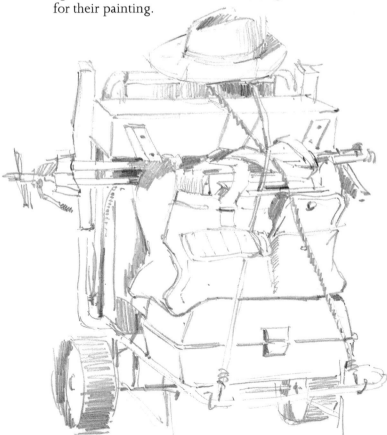

Fig. 66 Pencil on cartridge paper, 35 × 25 cm (13¾ × 10 in)

One of my students made an ingenious contraption for carrying watercolour equipment, which I have sketched in **fig. 66**. It held everything. It was great for very short trips from the car, over good firm ground, but too cumbersome for walking to find a spot. You want to enjoy painting, so don't make it difficult to carry your equipment.

Spot Finding a painting spot can be one of the most frustrating parts of working outdoors – for professional artists as well as students. It calls for a great deal of self-discipline. When you are in the area in which you want to paint and you start to search for a suitable spot, choose the first scene you see which you think would make a good painting. If you don't choose that one, you could fall into what I call the 'round-the-next-corner' trap: if you decide not to paint the first scene because you think that there may be a better one, when you reach the next corner you may think there could be a better one still round the **next** corner, and so on, until your painting time runs out. I'm sure some of you who have painted outside have fallen into this trap – I have too! When a scene inspires you, don't look any further: you have been inspired, therefore it is something you want to do. Forget what may be around the corner; leave that for another time.

Comfort Imagine a professional pianist with an orchestra preparing to perform: his stool would be at exactly the correct height and distance from the piano, his hands would be warm and supple, he would be in a position where he could see the conductor easily, and so on. He would be completely comfortable. Now, you are an artist and similar rules apply. Most of us painted when we were children, but probably not always in a comfortable position. We may have been lying on the floor, with brothers and sisters or friends running over our work, knocking over the water jar; we may have had elbow-ache or neck-ache because of an awkward working position. This was fine while we were children but it has left us with a carefree attitude to our working position for painting.

You should sit on a comfortable stool or chair. Your paint box, with your water container, should be in an easily accessible position. If you can only perch precariously on the side of a steep hill in order to paint the view you want, you should not paint that scene, or else you must accept the fact that it will be difficult to keep upright on your chair, and that more than likely you will not do your best work. However, if it is a scene you decide you must paint, for whatever reason, then obviously paint it: if it takes an extra 15 minutes to prepare for painting and making yourself comfortable, then that's the way it must be.

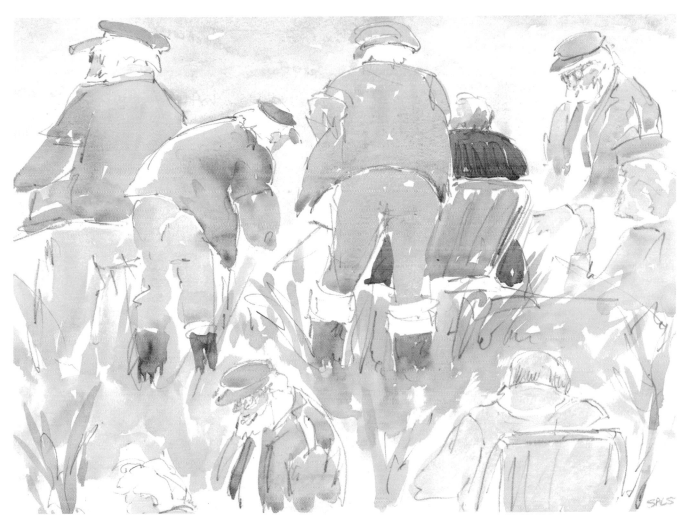

Fig. 67 My wife June took the opportunity to sketch me during a painting course. Pencil and wash on cartridge paper, 29 × 21 cm (11½ × 8¼ in)

Observation I must stress the importance of observation. It applies to indoor painting as much as to outdoor work. Perhaps it is more important when you are outside because so much is moving all the time – clouds, water, trees, people, animals, etc. – so you have to observe them quickly. Observation simply means looking and seeing things more carefully. If you simply glanced across the road, you might see a car parked, someone go into a shop, come back out holding a newspaper, and mingle with the crowd. But if you observed this same scene, in the same time-span, you would have seen that the car was red, a Ford saloon; above the shop window was the name 'Brown's Newsagents', in gold lettering on a brown board; two boys were standing in front of the window, wearing white T-shirts and jeans; the sun was out and cast strong shadows on the walls of the shop. This is how we have to look at our scene, even before we start to paint it, though naturally you

continue to observe throughout the painting. So after you have found your spot and made sure you are comfortable, sit back and spend time observing the scene, to make yourself familiar with what you are going to paint.

Initially, decide how you intend to paint your scene: what areas to paint first, how you intend to tackle certain parts of it, and so on. If you can't understand what an object is, then get up and move around until you can see what it is. Also you must decide how you are going to simplify certain objects (see Lesson 18). This may take up to 15 minutes, but it is as important as spending time getting comfortable.

 If you follow these rules, you can be sure to reach your painting spot with enough time to work, and to sit in comfort with all preparations made for the first brush stroke.

WHAT IS A SKETCH?

The word 'sketch' is used in all sorts of painting situations, and not always the correct ones. It is used most frequently when a student has begun a painting and has then lost concentration, or lost interest in the subject. Consequently the painting is not 'complete', or is lacking in feeling and atmosphere, or lacking drawing ability or observation on the part of the student, who then remarks, 'Oh, it's only a sketch!' Frequently, a painting is called a sketch to excuse poor painting. There is nothing wrong in creating a poor painting. But it is a poor painting, and it must not be called a sketch as a cover-up!

A sketch has a definite and most important part to play in the creation of a painting. It is the beginning. If you are working from your imagination or memory, as soon as you have a subject in mind, in order to portray your thoughts you have to commit them to paper. This then becomes your sketch, which you can work on for as long as it takes to satisfy you, so that afterwards you can work a painting from it. The sketch has gathered information (its most important role) from your imagination.

Some artists take only a sketch book and pencil with them when they go out; others take all their watercolour equipment. It doesn't matter what equipment you use; the object is to gather information in your own way.

After much careful thought, I have broken down the sketch into three distinct, practical types:

Information sketch A drawing or painting made solely to record information or detail, which can be used later at home or in the studio.

Atmosphere sketch A drawing or painting worked specifically to instil atmosphere and mood into the finished result. It can be used for atmosphere and mood information, or as inspiration for another painting.

Enjoyment sketch A drawing or painting worked on location, for pure pleasure.

All sketches, whether they are drawings or paintings, can be used as 'finished' works; in fact, some artists' sketches are preferred to their finished paintings.

The sketch in **fig. 68** is an information sketch. I used a 2B pencil on cartridge paper and from this I worked an oil painting 61 × 91 cm (24 × 36 in), in the studio. I also took a photograph (slide) of the scene, for extra detail information.

The information sketch in **fig. 69** is a drawing of a plane tree. I don't think I shall ever use it in a painting,

Fig. 68 Information sketch. *Teignmouth, Devon.* Pencil on cartridge paper, 41 × 30 cm (16¼ × 11¾ in)

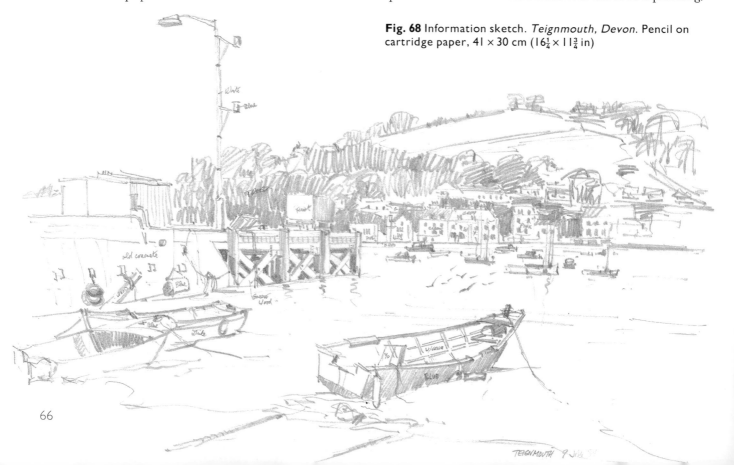

but the tree was so large and impressive that I had to sketch it. I used a 2B pencil on cartridge paper.

One April morning while I was working on this book, the weather was not kind for painting outdoors. But I was inspired as I looked out of my studio window (**fig. 70**). The strong light had silhouetted the people walking along the sea-front; the sky was the same grey colour as the sea, which was broken only by large white, foaming waves; and the wet road sharply reflected the buildings. I knew this effect would last only a short while, so I dropped my pen, picked up my sketch book, made the drawing and then painted over the pencil work. It took 23 minutes, and before I had finished the magic had gone from the scene, but I had captured it in this atmosphere sketch, for ever.

I am often asked, 'When is a sketch finished?' Well, the answer lies with you: when you have gathered enough information to work from at a later stage, without the model (the scene). Therefore the sketch can appear to be overworked for some artists or understated for others. I am asked the same question about a finished painting. Indeed, it can be very difficult to lay down rules about when a painting is finished because we all want to achieve different goals. Some students want a lot of detail in their work and

Fig. 69 Information sketch. Pencil on cartridge paper, 41 × 30 cm (16¼ × 11¾ in)

Fig. 70 Atmosphere sketch. *From my studio, Dawlish, Devon.* Cartridge paper, 29 × 21 cm (11½ × 8¼ in)

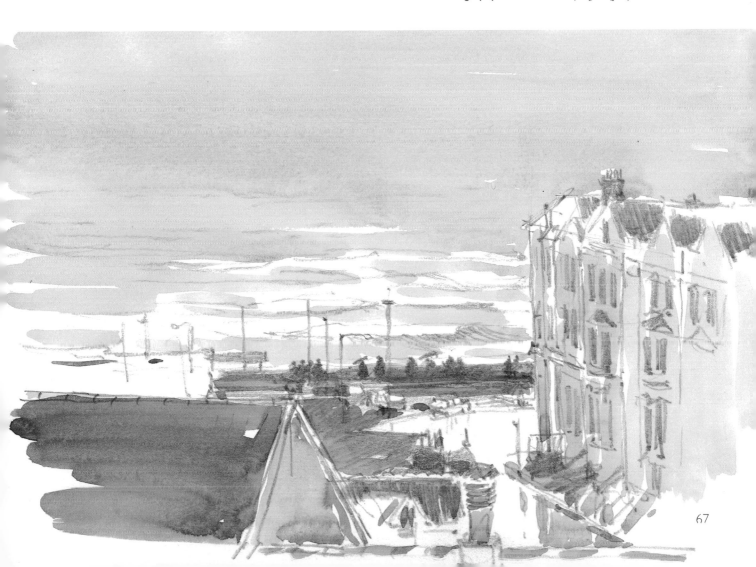

others try to achieve a painting with as few washes and brush strokes as possible. The answer lies again with the artist. But as a guide, I believe that when you are having to look for things to do, rather than knowing what you still have to do in the painting, that is the time to stop. You can take a break for a few minutes and return with a fresh eye. If nothing worries you, then stop there.

Fig. 71, below, is another atmosphere sketch on cartridge paper. I put some shading on the rocks with a 2B pencil before I used my watercolours. Notice how simply the people are painted.

Figs. 72–4 are enjoyment sketches. The Frenchman with his bread basket (fig. 72) couldn't be painted more simply. I made this sketch just for the sheer joy of doing it, as a demonstration for some students. I drew in the shape of the man with a 2B pencil on cartridge paper, and then added a wash.

June and I had just looked round the Uffizi Gallery in Florence, Italy, and were having a cup of coffee in its roof-garden restaurant. I saw the tower of the Signoria Palace and decided to paint it (fig. 73). I don't think I shall ever work a painting from it, but I really enjoyed doing it, and to me it's a better souvenir than a photograph.

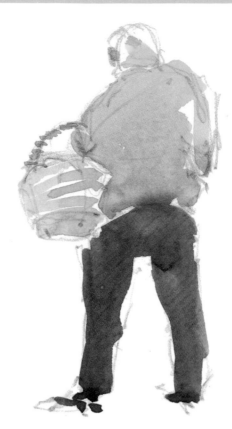

Fig. 72 Enjoyment sketch. Cartridge paper, 29 × 21 cm (11½ × 8¼ in)

Fig. 71 Atmosphere sketch. *Hay Tor, Dartmoor, Devon.* Cartridge paper, 29 × 21 cm (11½ × 8¼ in)

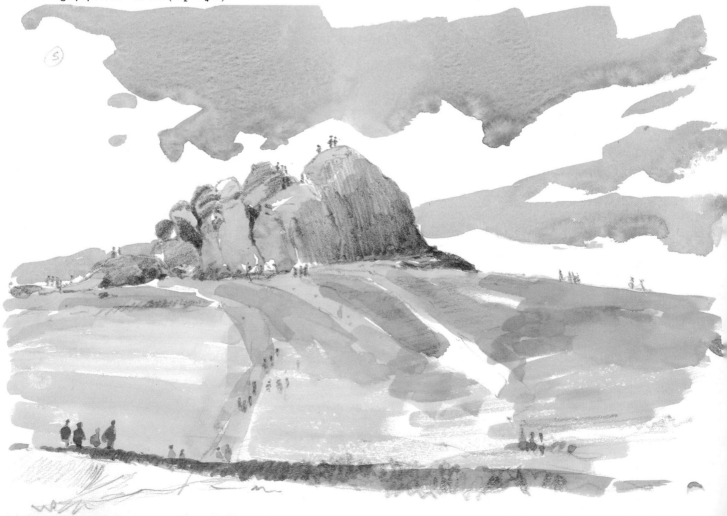

Never make notes on the front of watercolour sketches: you could easily have a watercolour sketch turn into a first-class painting, as often happens, so you don't want notes written all over the picture. Put your notes, if you need them, on the back of the sketch. On my sketches I use an ⓢ symbol for the position of the sun. This is important because when I want to use the sketch at a later date, if I haven't shown any shadow areas by shading, then I shall still know the position of the sun. If you are painting a 'real' place, then the sun must be in its correct position in your painting, otherwise someone will catch you out and tell you that the sun sets in the west here, not the east!

Finally, don't let the words 'sketching' or 'painting' confuse you or inhibit your work. Whenever you go out sketching or painting, you are going out to enjoy creating a picture, no matter how simple or how complicated. If you want to gather specific information, then you are going out sketching, otherwise you are going out to enjoy yourself, either drawing or painting. If you paint a masterpiece and hang it in an exhibition, then it could be called a painting. But if, say, two years later, you use that picture to paint another version of it, perhaps a larger one, or with a different atmosphere, then the original painting becomes a sketch! The dividing line is very fine. In the end, only the artist knows whether he has produced a sketch or a painting.

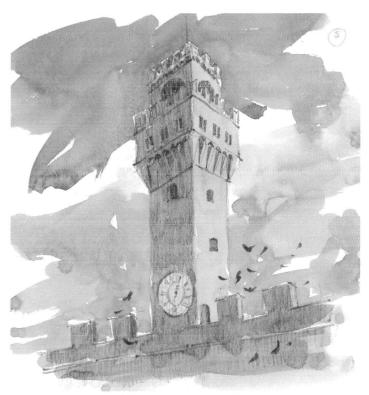

Fig. 73 Enjoyment sketch. *Palazzo dei Signoria, Florence.* Cartridge paper, 21 × 29 cm (8¼ × 11½ in)

Fig. 74 Enjoyment sketch. Pencil on cartridge paper, 29 × 21 cm (11½ × 8¼ in)

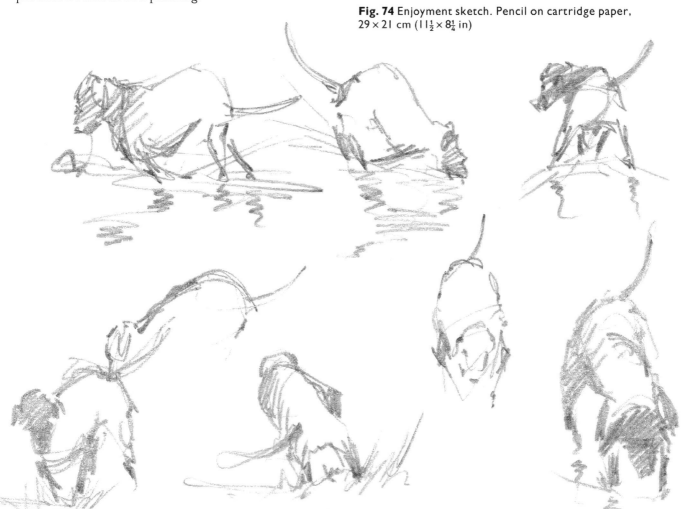

SIMPLIFYING WHAT WE SEE

When you are painting a field, you know that it is made up of millions of blades of grass, and of course you wouldn't even think of trying to paint them all. So you have to simplify the field and paint an impression of it. This applies to all subjects and all painting (except for the style called super-realism, where artists do attempt to paint almost every blade of grass; some of the results are quite fantastic). However, back to the field. To create the impression of a field with watercolour, a few broad brush strokes are often sufficient.

Students on my courses go out and work from nature, with me at their side, showing them how to simplify the landscape in front of them. For this book I have taken some photographs: you must imagine that we are outside together and I will show you how I have simplified the scene. Simplifying it doesn't mean making the painting easy. It means observing the subject and finding a way to create it on paper. Sometimes, like the field, it will be easy – just a couple of brush strokes – but in other cases you will find it more difficult to simplify what you see; it will need more thought to paint an impression of nature.

There is one excellent way to learn how to simplify nature, and that is by practising the half-hour exercise, which merely means that you paint the scene in front of you in half an hour. When I suggest this to my students, their reaction is disbelief, but when I take out the stop-watch, they get down to it. I have never found

a student who wasn't pleased, surprised and excited with the result. Quite often I am surprised by a student's half-hour painting. The exercise has the effect of giving freedom and unity to a painting, and no one has time to fiddle and fuss around, which can over-work and spoil a painting. The time limit forces you to learn to observe, to look for the important shapes and forms, to simplify the subject. I suggest – no, recommend – no, insist that you do some half-hour exercises. Choose any exercise in the book and do it again in half an hour.

I gave myself this challenge a couple of years ago, for my book 'The half-hour painter'. June and I went around Europe, painting everything in half an hour. I found it stimulating, and I gained a great deal from it.

On the following pages I have chosen subjects that we find when working outdoors, and painted them. I took a photograph of the subject, not to copy from, but to show you where and how I have simplified the scene and portrayed it in watercolour. You should find that simplifying your subject is a natural progression, along with all the other aspects of learning to paint in watercolour. For instance, as your ability to use your brush and, let's say, your colour mixing, improves, then your control over what you paint on the paper will increase and thus your ability to create simplified forms. Simplification will come with experience. In all these lessons, the more you paint, the quicker you will progress.

Fig. 77

Fig. 75 (opposite, left)

Fig. 76 (opposite, right) Look at the trees in the photograph (**fig. 75**) and then notice how I simplified them in this painting. Cartridge paper, 29 × 21 cm (11½ × 8¼ in)

Fig. 78 *The docks at Bristol*. Here you can see how I simplified the background behind the ships. Cartridge paper, 29 × 21 cm (11½ × 8¼ in)

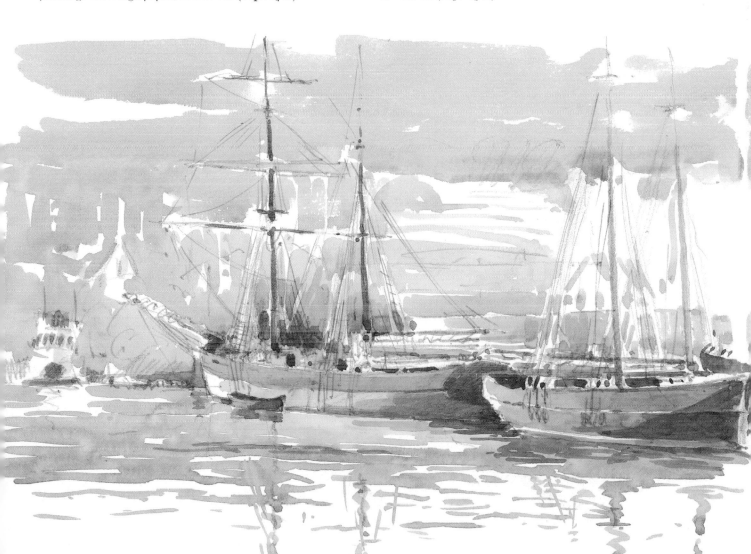

SIMPLIFYING LANDSCAPE

Fig. 79 (right)

Fig. 80 (below) Detail from the finished stage, **fig. 82**

Fig. 81 (opposite, above) Stage 1

Fig. 82 (opposite, below) Finished stage. Bockingford 200 lb, 30 × 18 cm (12 × 7 in)

I have simplified a landscape first, because usually our first glimpse of the countryside is a confusion of trees, hedges, houses and fields. Often I hear a student cry, 'Help! How can I paint all that?' – a natural reaction. A vast landscape is a common obstacle for students but after you have tackled this lesson, you should have gained enough confidence to cope with almost any landscape you come across.

In Lessons 20–27 that follow, I have taken various elements of landscape and treated them separately, e.g. trees, sky, water, people, animals, etc., and if you prefer to choose your own order of painting those eight lessons, then please do – there is no significance in the order in which I have presented them.

If you look at the photograph above (**fig. 79**) and then at the finished stage (**fig. 82**), you will see that the trees and hedges in the background, down to the dark trees behind the house, have all been painted in with one wash (only one application with the brush) and not touched again. With that information alone you can see how a landscape can be simplified. You can also see how important it is to learn to use (to draw

with) your brush, because it was the brush stroke that created the trees and hedges (brush stroke **k**).

Now let's look at Stage 1 (**fig. 81**). I decided not to paint any sky because it would have cut off the top of the painting, so I started with the blue-coloured hills. Remember that as objects recede into the distance their colours become cooler, and everything in the foreground has warmer or more 'real' colours. For instance, a red brick wall ten feet away will look red. If you look at the same wall two hundred metres away it will not be so bright or so 'red', it will be more greyish; in the far distance it will be just a 'dark grey' tone, it will have lost its individual (local) colour. It is important to remember this. As a guide, add blue to the distant colours to cool them, and red to warm up foreground colours.

I treated Stage 1 almost as a flat wash, with plenty of water, changing colour as I painted down the paper. I made sure that I kept the bright colour of the ploughed field and the bright green field below it. Notice how the colours have run into each other; this helps to hold the scene together. Also see how I left white paper in 'lines' following the contours of the fields. This was deliberate but not planned: where it happened – it happened. When I reached the foreground field, I painted this in with just three brush strokes, following the slope of the hill. I didn't touch this again. I waited for the paint to dry and then put in the trees and the rest of the buildings. When this was dry, I added darker tones to the trees behind the house and the hedges to the right of the picture.

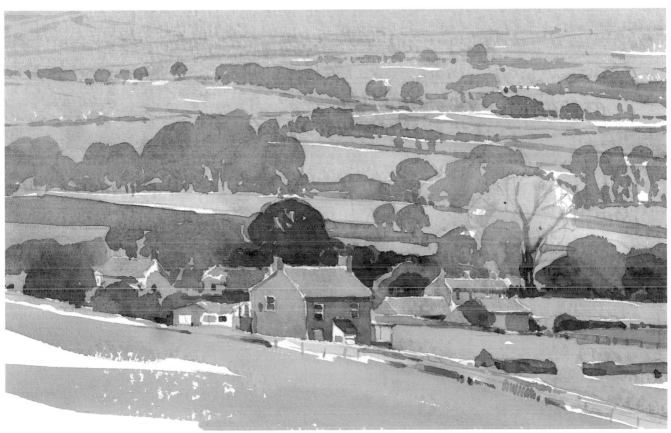

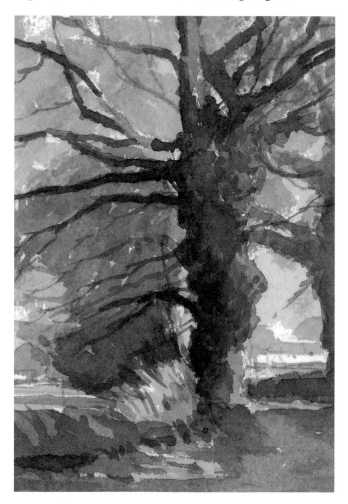

I felt that the most important area to simplify in this next landscape (**fig. 83**) was the sunlight on the foreground hedge. The shadows were moving across the road and it was much better to paint the hedge in shadow than in sunlight. It was much easier to do – because otherwise the light colour would have had to be painted first, then the dark of the fields painted into the light colour of the hedge, which would have been a very difficult area to work – but above all, the hedge would have been too prominent for the picture. In Stage 1 (**fig. 85**) I painted the sky very freely, using French Ultramarine and Crimson Alizarin, then I painted the hills and fields. I made sure I didn't paint over the distant buildings, as I wanted to leave them white paper. When this was dry I painted the trees in the distance.

In the finished stage (**fig. 86**) I painted in the main trees – and notice how I kept the right-hand tree 'cool' in colour compared with the foreground tree, thus helping to keep it further down the road. I put some modelling into the hedge and road, and when this was dry I painted over a wash, using a mix of French Ultramarine, Crimson Alizarin and a touch of Yellow Ochre. This gave the illusion of a shadow. As soon as this wash was applied the fields appeared brighter, as though in sunlight. This effect, of course, was helped by light against dark. In Stage 1 the fields were dark against the 'white' of the unpainted hedge; when the shadow was painted they became light against the dark hedge.

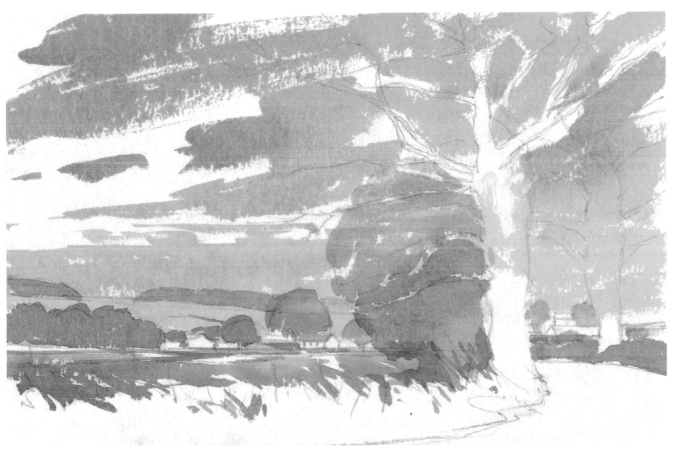

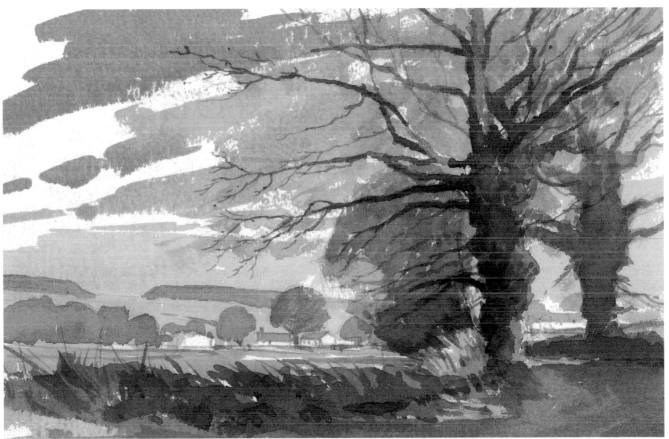

LESSON 20

SIMPLIFYING FOREGROUND

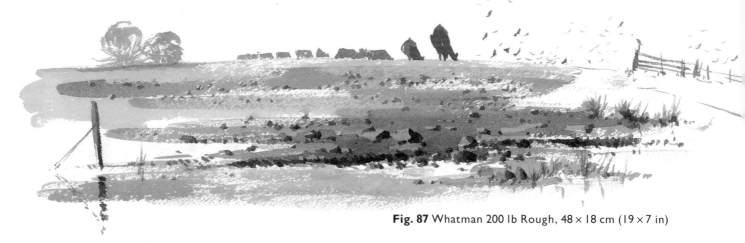

Fig. 87 Whatman 200 lb Rough, 48 × 18 cm (19 × 7 in)

In a watercolour painting, dependent upon the subject, it is accepted that 'free' brush strokes can represent the foreground of a painting, as the foreground field in Lesson 19, page 73. Naturally, there are subjects that demand more modelling and detail but, even so, never over-work the foreground. It is sometimes tempting to take a small brush and fiddle, trying to paint in just one more blade of grass, but even if the foreground looked great because of your detailed attention, the chances are it wouldn't be in sympathy with the rest of the painting – simply because you didn't give all of it the same attention to detail. The painting must appear as a whole, not as different ones put together.

It is very important to check your scale when working a foreground. For example, if you are painting a pebbly beach, the pebbles will appear smaller as they recede. Make sure that a pebble at the side of someone's foot isn't painted too big, or it will look like a rock! This all sounds obvious, and of course it is, but it is one of the biggest pitfalls for a student. Observe and check what you are looking at all the time. Look at the foreground in front of you, and see how you could simplify it. If it takes half an hour to work it out in your mind, it is worth every minute.

The foreground in **fig. 87** was done as an impromptu demonstration to a class of students. I painted three separate washes – applying each one when the previous one was dry, and each time leaving some areas unpainted. This left shapes that looked like clumps of earth and stones. With a final wash I selected some of these 'missed' areas and added a shadow, which gave it form and dimension. Note how the stones and lumps of earth become smaller as they go up the hill. I then added the cows going over the hill to show scale and distance as the cows get smaller. The gate was also put in to show scale. Remember scale in your paintings: it enables the onlooker to understand your picture.

Fig. 89 shows a more simplified way (with fewer washes) to give the impression of rocks on a muddy estuary. As I painted this exercise simply to show you how I tackled the foreground, I did not add anything else to show scale. If it had been a painting I would have put in a couple of seagulls, or a boat closer than the one in the photograph, or someone walking on the mud.

In **fig. 90** I think I have gone a little too far and slightly overworked this foreground. I started simply, leaving plenty of white paper for the long 'yellow' grasses, and when the paint was dry I continued to model the grass with darker washes. I'm happy with it, but I should have stopped myself from getting 'fiddly' – we can all fall into the trap!

Fig. 88 Detail from **fig. 87**

Figs. 89 (left) and **90** (right) Top to bottom: Photograph; Stage 1; Finished stage, Whatman 200 lb Not, 18 × 11 cm (7 × 4½ in); Detail from the finished stage

SIMPLIFYING TREES

Fig. 91

Trees are one of my favourite subjects for painting.
Perhaps it's because I like painting landscape, and trees
are a very prominent and important part of most
landscape scenes. Like all subjects, you must observe
them carefully in order to draw and simplify them (see
figs. 92 and **94**). I have one golden rule that I
recommend you follow: when you are drawing or
painting trees without leaves, always work from the
bottom of the tree upwards and outwards in the
direction of the growth of the branches. You then give
them a natural flow and growth movement.

Try this experiment: take your brush and fill it with
paint, start a long stroke left to right and continue until
the paint runs out, or until you lift the brush off the
paper. You will see that a natural brush stroke starts
thick (because a full brush puts the most paint on to
the paper and you use most pressure when you first
apply the brush). As you finish the stroke, it gets
thinner (less paint), and split seconds before you lift
the brush off the paper you begin to relax the pressure
(thinner line). This description is exaggerated a little to
explain why, if you were to start at the top of a thin
branch and work down, painting a whole tree in this
way, it would look totally wrong.

When you paint trees in leaf, let the brush strokes
follow the fall of the leaves.

If it is practical, first practise drawing bare trees with
a pencil. You will then understand what is going on
behind the foliage in summer.

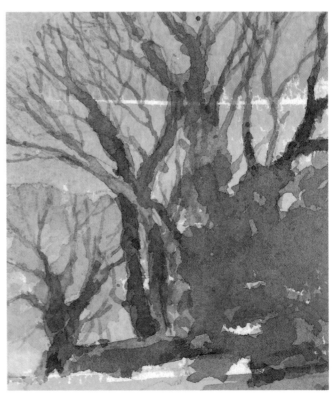

Fig. 92 (above) Detail from the finished stage, **fig. 94**

Fig. 93 (opposite, below) Stage 1

Fig. 94 (opposite, below) Finished stage. Whatman 200 lb
Not, 30 × 18 cm (12 × 7 in)

When you are drawing or painting trees from life, don't try to copy every branch or leaf – it's impossible. Make sure you observe the shape and character of the tree and aim for this in your drawing. It doesn't matter at all if you find you have drawn some of the branches at a different angle, or a bit larger or smaller than the real-life tree; this is bound to happen. It's the overall impression of the tree that you are trying to achieve.

At first, don't put in a painting any trees that are in the foreground. Start with trees in the middle distance, such as the ones in **fig. 94**, page 79, and **fig. 86** on page 75. At this distance you will be concentrating on the overall shape of the tree and discovering how its branches grow. Then you can gradually work closer until you are working only metres away and concentrating on parts of the tree, how the branches are formed, leaves, bark, and so on. In **fig. 94** you can

see how I have kept the main characteristics of the hedgerow of trees. I painted the main trunks with my No. 6 brush and the small branches with my rigger.

Fig. 95 shows how, with only one wash, a middle distance can be created. First paint the tree with branches only. While the paint is still wet, paint over the branches with a light green wash. This will flood into the branches and create depth to the tree. If you wish, you can use this as the basic wash, and when it is dry continue to work on the tree, adding more detail and depth. Practise this; I am sure it will be well worth it. The two hedgerows in **figs. 96** and **97** I painted on cartridge paper, near my home. For the oak in **fig. 95** I relied on paint to model the tree, but in **fig. 97** I let the pencil create it and didn't over-paint it too much, otherwise I would have lost the pencil and a lot of the delicate form.

Fig. 95 Whatman 200 lb Not,
23 × 20 cm (9 × 8 in)

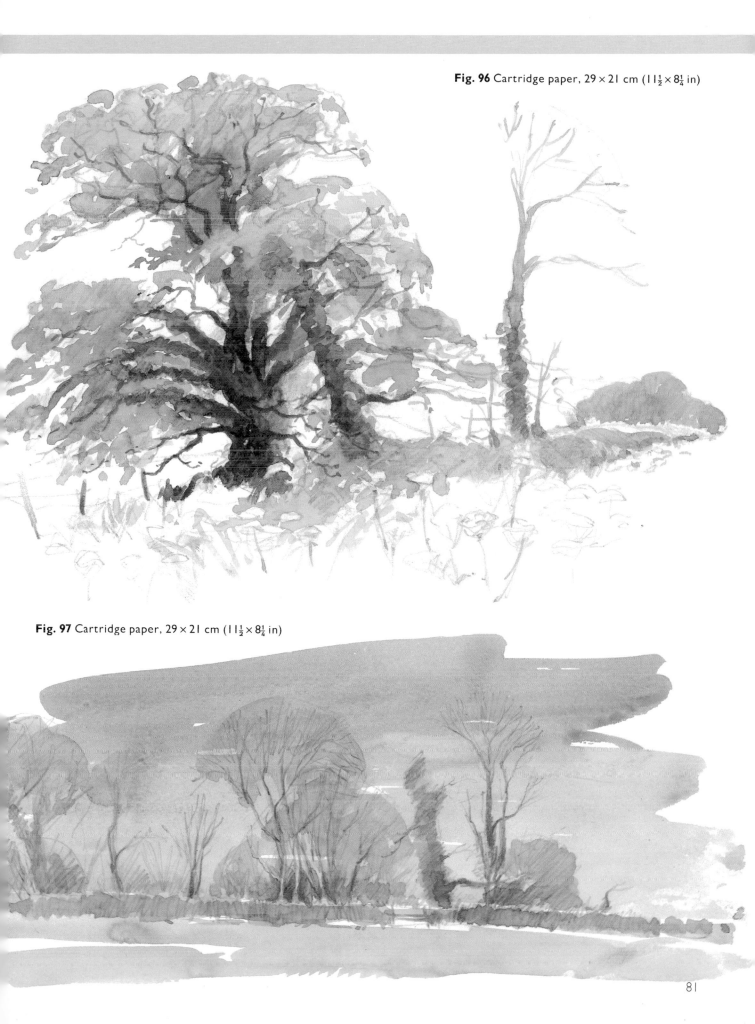

Fig. 96 Cartridge paper, 29 × 21 cm (11½ × 8¼ in)

Fig. 97 Cartridge paper, 29 × 21 cm (11½ × 8¼ in)

SIMPLIFYING WATER

The most important feature in painting water, and in particular when using watercolour, is not what you paint but what you don't paint. Water has to be painted very simply otherwise it looks muddy and unnatural.

Look at **fig. 100** opposite. You can see how simply you can paint water; in fact, the water, top left, has been created by leaving white paper, but the secret ingredient is the reflection of the yacht. If a painting has a reflection in the water, that will give the impression of water. Look at the first pole on the left. The reflection is a copy of it; this is the simplest way to show water. But if you look at the second and third poles to the right, the reflections show movement, portrayed by breaking the vertical reflections to create the effect of light and movement of the water. This is the most common way of creating a reflection and, even on white paper, it creates the impression of two poles standing in water. The pole on the extreme right is at an angle, so the reflection is painted at the opposite angle: a rule which applies to all reflections.

The yacht, top right, is simply a white silhouette on a blue background with a white reflection but, immediately, the reflection tells us that the blue is water. Another clue to the illusion is, of course, the yacht, because that's where you would find one. Yes, it is obvious, but it is these obvious things that help us to create our paintings. Without the yacht or its reflection, the water would be simply a blue panel.

The angler is standing in water, but the water has been left as white paper – only the reflection informs us that it is water. Take away the reflection and he could be standing in snow. The cruiser has only a simple reflection on white paper to show it is in water.

At the bottom, the white post and dark pole each have a reflection in blue water, but the white posts to the right of them have no reflection and they look wrong. Cover up the two left-hand posts and the white ones on the right look completely wrong; there is no indication of their being in water at all. Remember, the water can be as simple as you like, even unpainted paper. But you must have a reflection, and you can still paint this simply and directly, without fuss.

The waterfall in the photograph, **fig. 98**, looks daunting to paint. Still, the way ahead is to simplify. Notice how strong the trees are in the photograph and how I simplified them in colour and tone so that they recede into the distance (**fig. 99**). After the trees, I painted the first wash of the water, leaving plenty of white paper unpainted. I let that dry, and then painted in the rocks. This immediately made the water sparkle (dark against light). I then modelled the foreground water a little more and darkened some close-up rocks.

Fig. 99 Bockingford 200 lb, 20 × 28 cm (8 × 11 in)

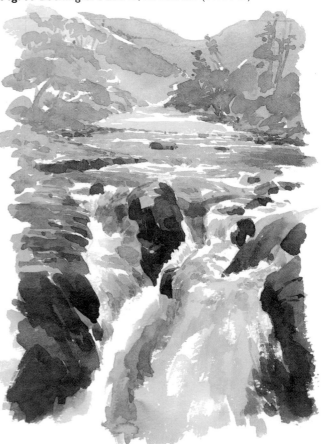

Fig. 98

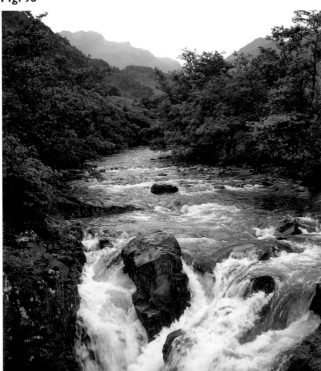

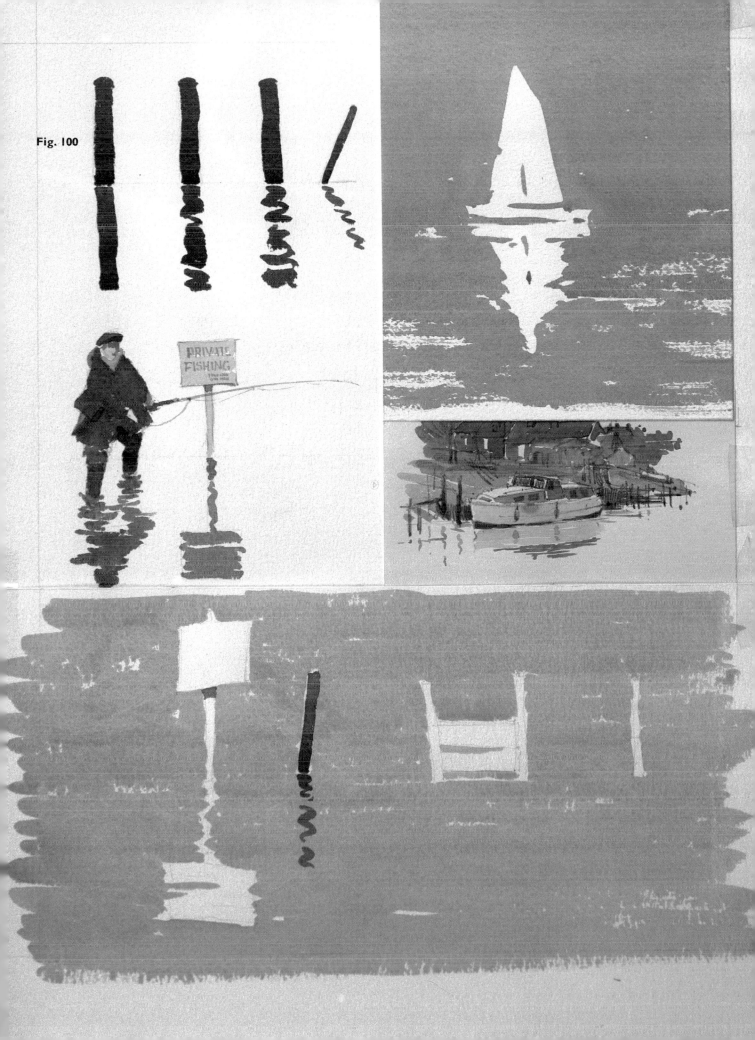

Fig. 100

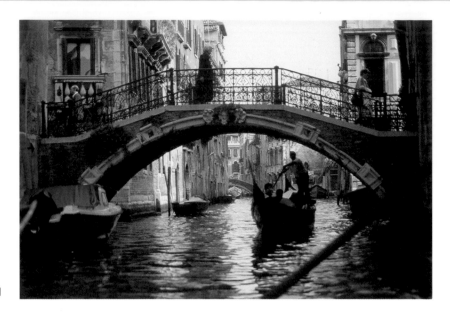

Fig. 101

In the photograph of Venice, **fig. 101**, we have a good example of what we have just been considering. Taken individually, the reflections in the photograph are very similar to the ones in **fig. 100**, the post and the angler, but instead of leaving white paper for the water, I painted the whole of the paper in the colours of the surrounding buildings. This was done after I had put the first wash on the buildings, bridge and boats in Stage 1 (**fig. 103**); I did this by making the colours very

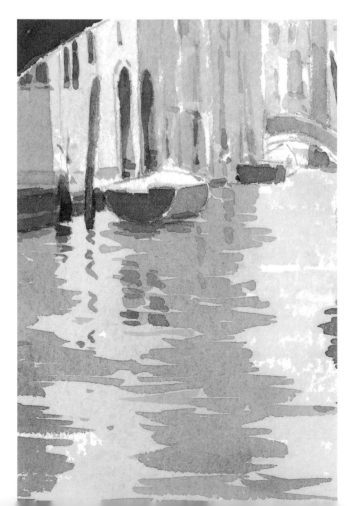

watery and allowing them to run together (the paper was not wet first). Then I finished working the buildings and painting in the gondola.

It was then reflection time. Whatever you do, when you are ready to paint a reflection you must be relaxed because, with most watercolours, it has to be correct first time. There is no second chance. Knowing this, you may find it difficult to relax, so what is the answer? Try a 'dry run' as I do: I mix my colours first, then I work over the reflection, not touching the paper but working my brush and brain as though I were actually painting the reflection. It's simply a rehearsal. Depending on your ability, you may have ten or twenty rehearsals before going ahead. But by that time you will know what you have to do; you will be familiar with the brush strokes you need to make. You will have confidence and, of course, confidence will make you relax. Believe me, this does work.

I painted in the reflection in two stages with my No. 6 sable brush (**fig. 104**). When the first wash was dry, the second stage was simply to paint over it in places. The tonal values in the photograph are much darker than in my painting but, remember, I was not copying a photograph; I am using it as a guide for you.

Practise simple reflections, and when you are happy with your portrayal of water you will probably try to get some in every painting!

Fig. 102 (left) Detail from the finished stage, **fig. 104**

Fig. 103 (opposite, above) Stage 1

Fig. 104 (opposite, below) Finished stage. Whatman 200 lb Not, 30 × 18 cm (12 × 7 in)

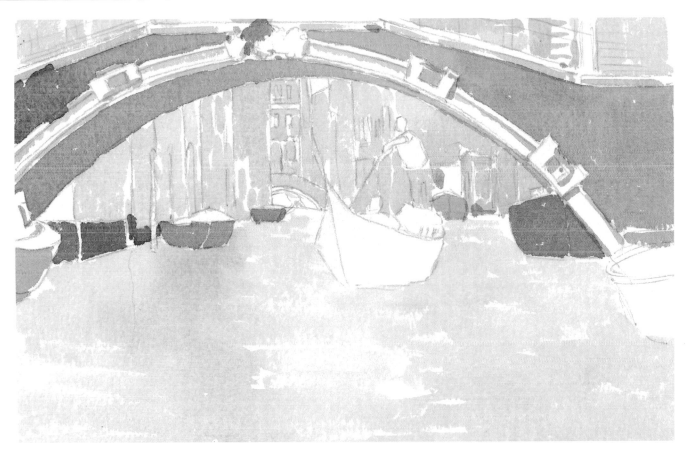

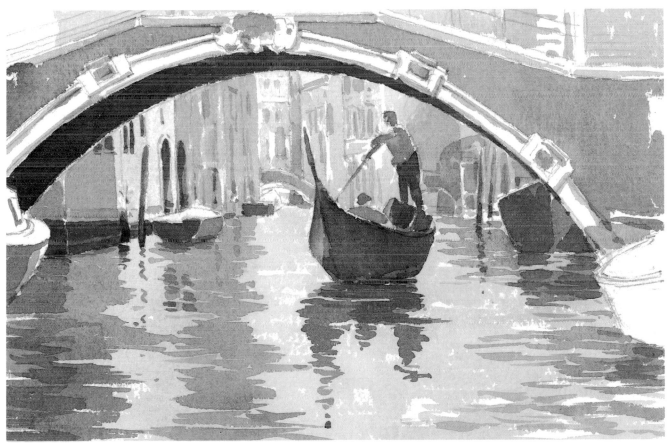

SIMPLIFYING BOATS

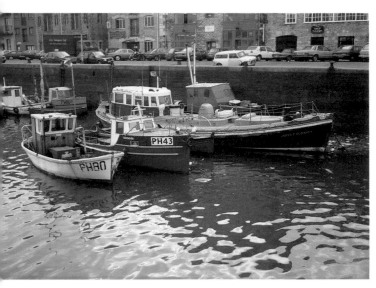

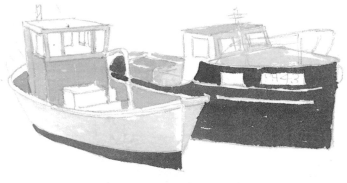

Students are often reluctant to try painting boats. I believe one of the reasons is that if you go to a harbour area or estuary, there are so many boats in view that the thought of painting them is frightening. Because all students' natural urge is to paint a picture, they are reluctant to pick out one or two boats to draw and paint. But this is how you should start; as you first drew single trees, draw single boats. Begin at a distance and gradually move closer, where you are able to see more detail.

If you are not very proficient at drawing, then I suggest you gain more confidence before attempting boats, because they require more drawing skill than trees, for instance. Take your cartridge paper sketch book, sit where there is plenty of boat activity, and practise drawing them. When you are confident about drawing boats, then paint them in very simple washes. Don't try to draw them too near to you, as I have done in **fig. 105**. Wait until you gain more drawing experience for this distance. Look at the opposite page, **fig. 106**. I have drawn and painted these boats in the middle distance, not close, in a very simplified way, using only one or two washes to create the illusion.

The only guide I can give you for drawing and painting boats is to observe them carefully: how they sit in the water, on a mud-bank, turning; their masts, their size relative to people, the people in them, and so on – before you put pencil to paper. Then practise and practise.

When you paint them, begin by painting them simply. By the way, notice how simple my reflections are. Also, in **fig. 105** did you notice that I omitted the 'white' reflection of the boat? It would have become confused with the water, which is painted in just one wash, and the reflection is only one wash painted over the first wash when dry.

Fig. 105 (top to bottom)
Photograph; Stage 1;
Finished stage, Whatman
200 lb Not, 20 × 13 cm
(8 × 5 in)

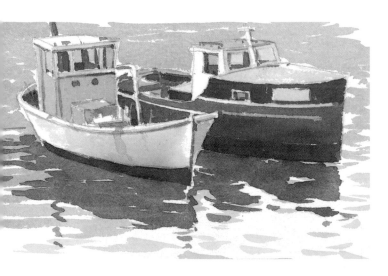

Fig. 107 Detail from **fig. 106**

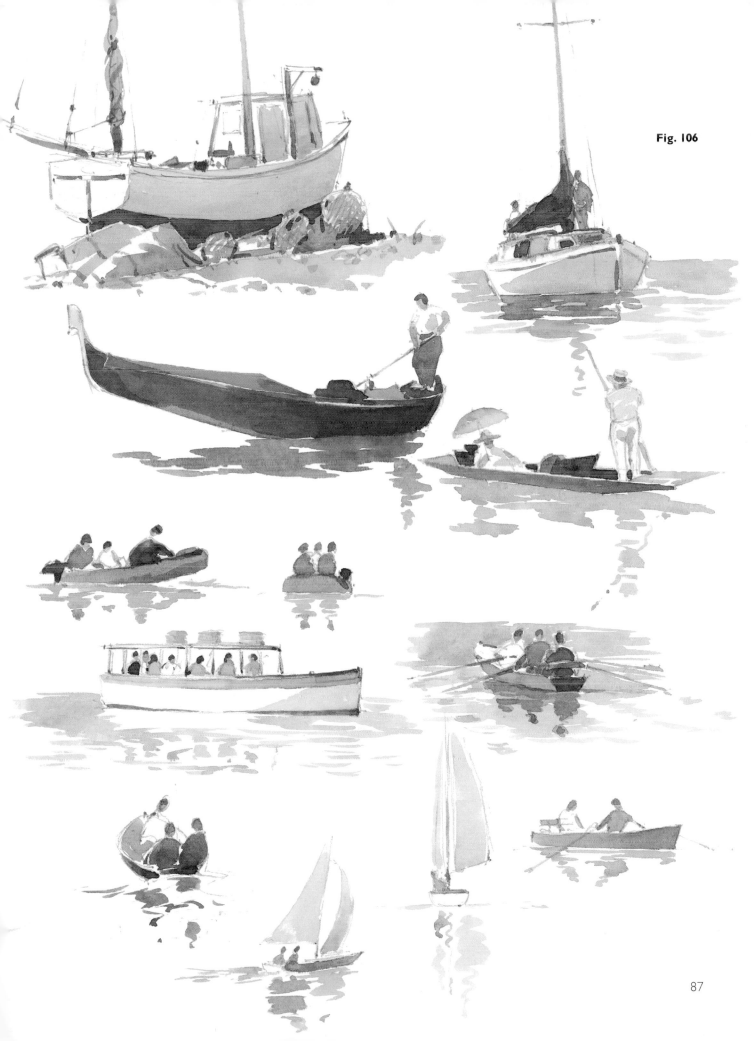

Fig. 106

SIMPLIFYING SKIES

Fig. 108

In a landscape painting, whatever the medium, the sky is the most important element. I have always felt this, even in my art school days. The sky gives the atmosphere and mood of the painting; and a painting without atmosphere or mood is not very convincing. This doesn't mean that the sky has to be a very complicated, detailed painting. In fact, some of the best 'moody' watercolour landscapes are painted very simply. Look at the exercise in **fig. 112**, for instance. I wet the paper first, then applied only one wash for the sky. Yet although it couldn't be done more simply, the mood of a rain-swept landscape has been created.

Unfortunately, clouds do not keep still for us to paint. If the clouds are high and there is not much wind, some skies seem to stay roughly the same for up to an hour or so, but when we try to paint a sunset or sunrise, the scene changes almost every minute. The only way to cope with this is to make a sketch in pencil first, using a 2B, and rather than draw the shapes of clouds before shading them, draw and shade at the same time by using the broad side of your pencil. Use a kneadable putty rubber to take out cloud highlights; this will help to get the form of clouds quickly.

When you work in colour, don't paint in detail but aim for the overall effect of the sky. You will be working very fast and colours will run into each other,

but there is nothing you can do about it. These are working drawings or information sketches. It doesn't matter what a mess you make, you are learning about skies. With these sketches and the visual knowledge that is now in your memory through observation, you will be able to use your sketches to work from indoors, and in your own time practise further at painting skies.

I suggest you start with skies which can be painted very simply, then you can progress and add more detail and character as you gain experience. In **figs. 109–12**, all four examples of different skies have been done with one wash only. Yet if you look at the sky in **fig. 110** for instance, this gives a lovely feeling of clouds blowing across the sky. But I don't like the tree I painted. The sunset, **fig. 109**, is a simple graded wash changing colour to the horizon. That in **fig. 111** is again a graded wash changing colour to the horizon, but painted with brush strokes that leave white paper showing to give the impression of light clouds. Notice that the clouds (white paper) get thinner as they approach the horizon – they are in persepctive, the same as houses, etc. When you work from life, start by simplifying skies as much as I have done, and build on that as your experience grows. In **fig. 113** the sky was created by applying only two washes. By the way, I like the trees better in this one.

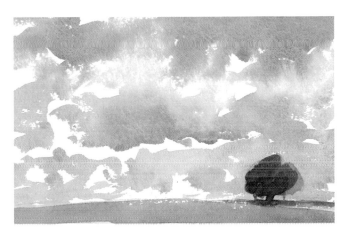

Fig. 109 (above, top left) Whatman 200 lb Not, 30 × 18 cm (12 × 7 in)

Fig. 110 (above, top right) Bockingford 200 lb, 30 × 18 cm (12 × 7 in)

Fig. 111 (above, bottom left) Cartridge paper, 29 × 21 cm (11½ × 8¼ in)

Fig. 112 (above, bottom right) Bockingford 200 lb, 30 × 18 cm (12 × 7 in)

Fig. 113 (below) Bockingford 200 lb, 30 × 20 cm (12 × 8 in)

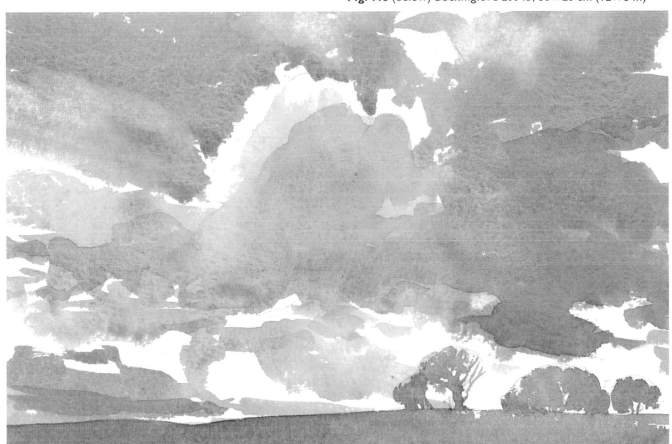

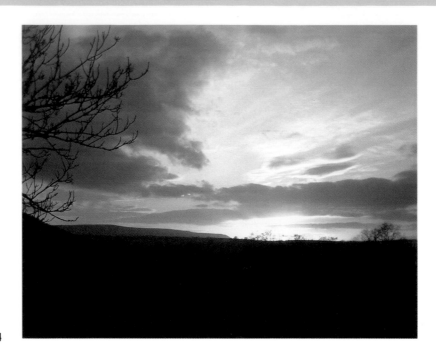

Fig. 114

Fig. 115 (below) Detail from the finished stage, **fig. 117**

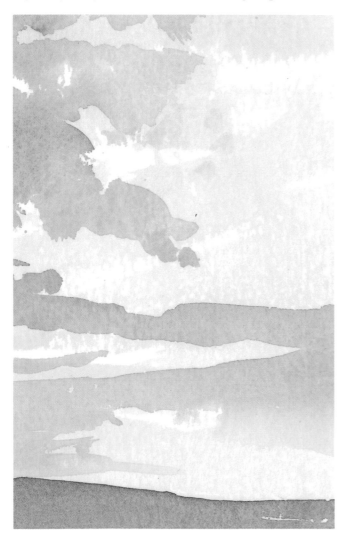

Sunsets can be difficult to paint not only because they are changing every few minutes; they are ready to catch the unsuspecting artist another way. You must have seen plenty of sunsets that take your breath away. The brightness, the radiance and richness of colour – I have seen some evening skies where the colour was so strong and vivid that no one would believe it unless they were there to witness it. A sunset like this can inspire any artist to capture it on paper or canvas. But that is the danger. I am afraid that when this kind of sunset is painted it can look overdone, crude and sometimes childish.

We can accept the extraordinary visions of nature, because we can see them – they're real; we can even accept them as being true in a photograph, but in a painting they can look false. If you see a sunset of this kind, enjoy it and get excited about it, but if you do paint it, play it down.

In **fig. 116** I painted the first wash, starting at the top and working down the paper, changing the colour as I worked. I let the colours mix together as the wash progressed. In the finished stage (**fig. 117**), when the first wash was dry, I painted over a second wash, again changing colour and density of colour, as I worked from top to bottom. I used my No. 10 sable brush, and let the brush 'draw' and follow the shapes of the clouds. This picture was painted with only these two washes.

Fig. 116 (opposite, above) Stage 1

Fig. 117 (opposite, below) Finished stage. Whatman 200 lb Not, 30 × 18 cm (12 × 7 in)

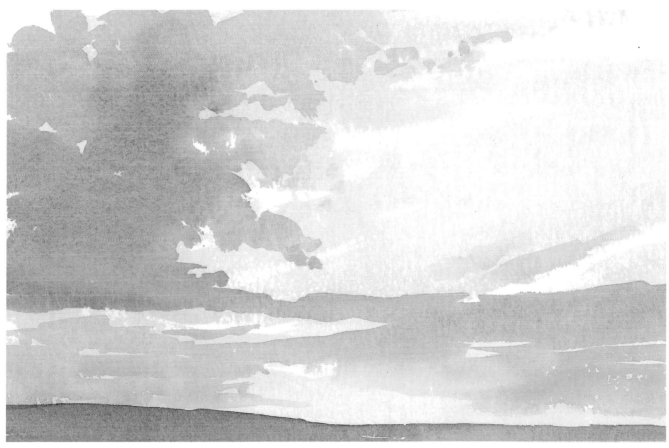

LESSON 25

SIMPLIFYING BUILDINGS

Fig. 118

Consider a street scene, with buildings of all shapes and sizes, people, traffic and all the usual flotsam and jetsam of a busy street. No matter how much it inspires you, this is not the subject to choose when you begin to paint buildings. Start by painting them individually. You can perhaps see some houses from your own window. If possible, sit and observe them. Notice how the roof overhangs the walls, how the chimney-stack rests on the roof; look at its size compared with the size of the windows, which are usually bigger than you imagine.

Now try painting some from your window, if you can. You will have the working conditions on your side. If you can't do this, then, when you are outside, find somewhere out of the way to sit and work. Ideally, go out into the countryside and work at country buildings, farms, houses, barns, churches and so on. These are usually individual buildings and easier to cope with, and you can usually find a quiet spot from which to work. When you have gained experience, then you can try a busy street scene.

When you are painting buildings, notice how the areas of colour or tone are broken up into shapes with crisp edges. For instance, look at **fig. 119**. In this first stage, the chimney-stack is a separate wash, the roof is another, the left-hand wall of the building is another self-contained wash area, and so on. This means that when you are painting buildings in watercolour, a little more discipline is required than when you are

painting a sky, for instance, when you want the colours to run and mix together. Most of the areas of buildings are quite separate and therefore each wash has to be kept in its own defined area. I did much of my basic watercolour training by working outside. Buildings are a good subject for watercolour discipline.

Look at **fig. 119** again, and you can see just how I have simplified the buildings. All the areas I have painted in Stage 1 are self-contained washes, even the sky. Notice how I left white (paper) edges in places where one wash meets another. This is done (very freely) to stop the two washes running together, but you should let them touch occasionally; this gives the painting more character. I didn't put in the roof window that can be seen in the photograph (**fig. 118**), as I felt it would look a little strong and odd in the painting. When Stage 1 was dry, I painted in the windows and door, **fig. 120**. I left the front wall of the main house unpainted (white paper). This kept the painting looking crisp and sunlit.

Another important factor which helped to simplify the building was leaving out the long shadow on the house. Because of its shape it would have looked very confusing. Have you also noticed that I didn't paint in the horizontal window frames? I left (white paper)

Fig. 119 (opposite, above) Stage 1

Fig. 120 (opposite, below) Finished stage. Whatman 200 lb Not, 30 × 18 cm (12 × 7 in)

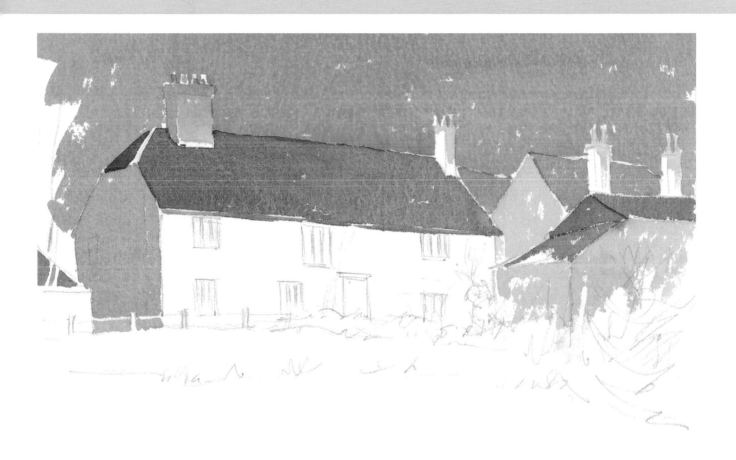

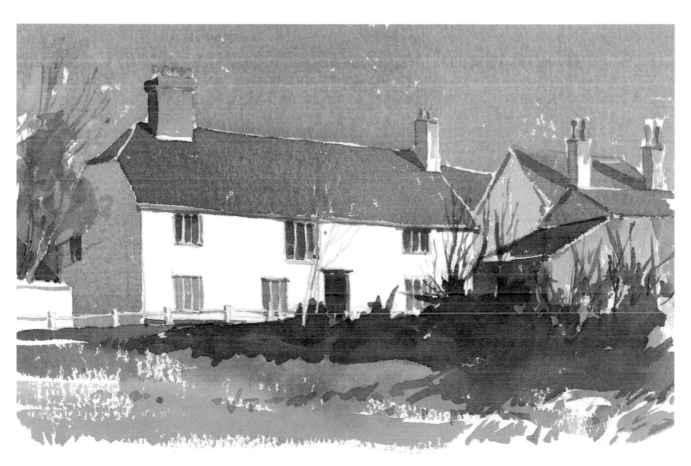

Fig. 121

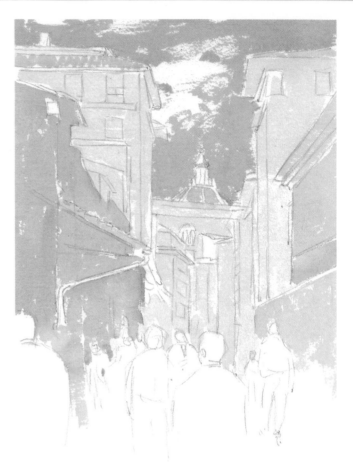

Fig. 122 Stage I

only the vertical ones. I didn't attempt to paint the slates on the roof or the bricks in the chimney-stack.

The painting in **fig. 124**, page 95, is of course much more complicated than the previous one, but if you study it carefully, you will see that it was built up in exactly the same way, using simple washes within defined areas. You **must** make sure that the paint is dry before you put on another wash, otherwise you cannot get crisp edges to your buildings.

Students often ask me how they can avoid pencil lines showing through the paint when a watercolour is finished. In fact, many students **purposely** draw very lightly with their pencil for this reason. Unfortunately, if you adopt this gentle approach you will find it leads to a drawing that lacks conviction and life; also, since the drawing is the very beginning of the painting, you will find it more difficult to paint with confidence.

There is no 'rule' to say that pencil lines should not show through a finished painting. In fact I, and many other artists, believe they actually help to give a watercolour character and life.

Fig. 123 (left) Detail from stage I, **fig. 122**

Fig. 124 (opposite) Finished stage. Whatman 200 lb Not, 23 × 30 cm (9 × 12 in)

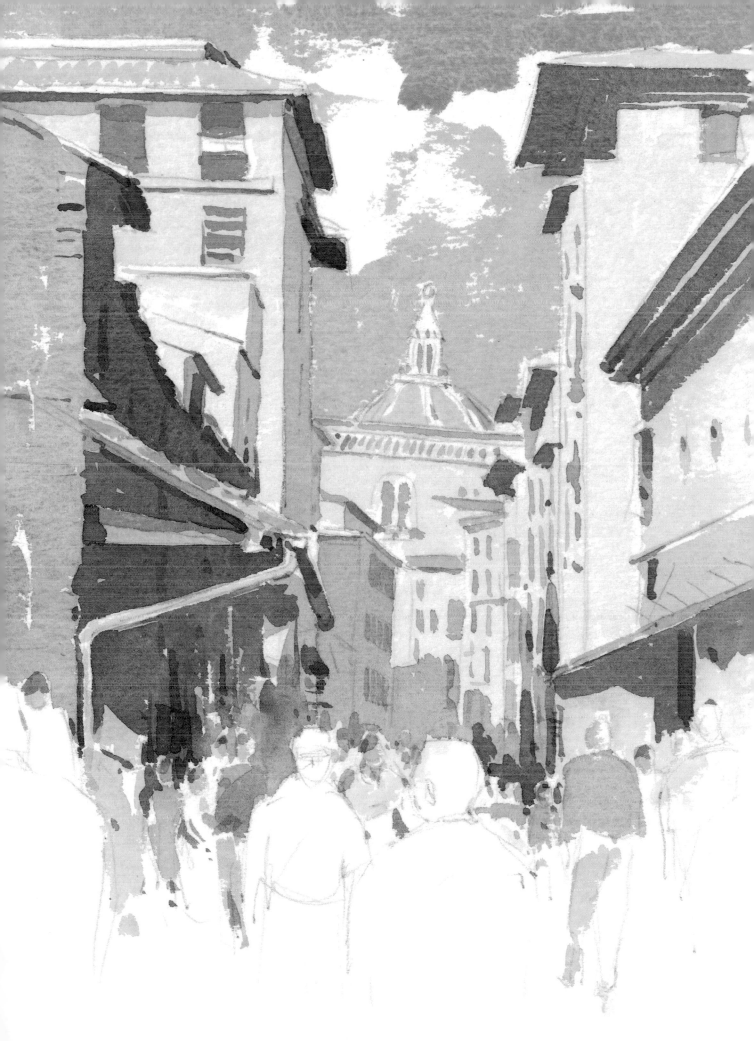

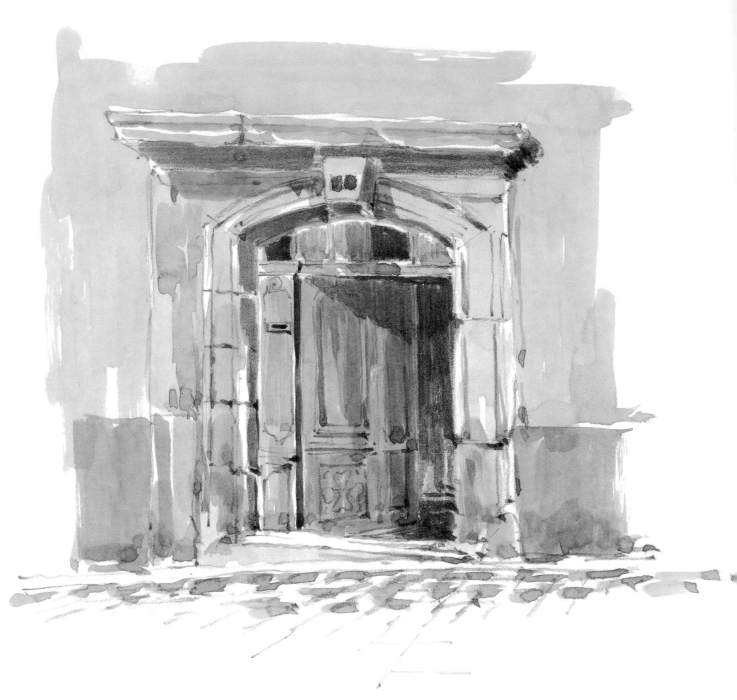

Fig. 125 *Doorway, Place St Michel, Forcalquier, Provence.*
Cartridge paper, 29 × 21 cm (11½ × 8¼ in)

Draw your picture as if it were a drawing, but without shading: then your drawing will be 'strong' and convincing. Whatever pencil lines show through when the painting is finished, leave. They are a very important part of your watercolour.

This applies even more when you are painting buildings, where there is usually more careful drawing to be done. When you draw a tree in a landscape, if two or three of your large branches are not drawn accurately, no one will notice, but if a couple of doorways and a window of a building are not drawn

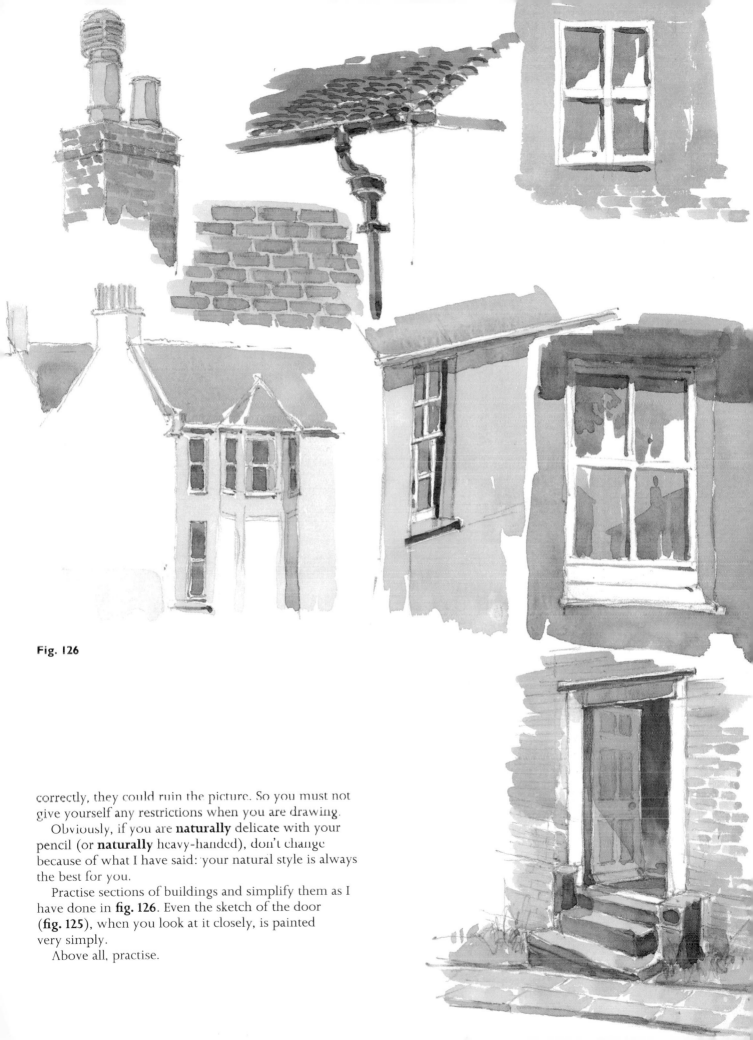

Fig. 126

correctly, they could ruin the picture. So you must not give yourself any restrictions when you are drawing.

Obviously, if you are **naturally** delicate with your pencil (or **naturally** heavy-handed), don't change because of what I have said: your natural style is always the best for you.

Practise sections of buildings and simplify them as I have done in **fig. 126**. Even the sketch of the door (**fig. 125**), when you look at it closely, is painted very simply.

Above all, practise.

SIMPLIFYING ANIMALS

Fig. 127

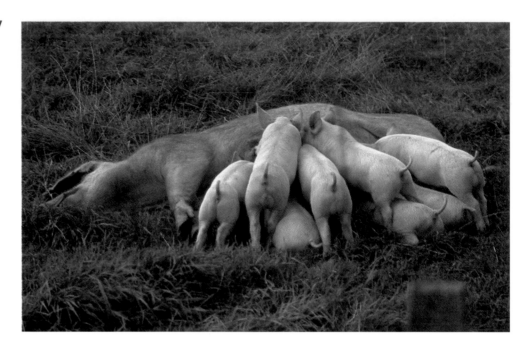

Fig. 128 (opposite, above)
Stage 1

Fig. 129 (opposite, below)
Finished stage. Whatman
200 lb Not, 30 × 18 cm
(12 × 7 in)

We talked about clouds moving as we paint them. Well, animals can move much quicker! This is, of course, one of the real problems when painting them. It is also one reason why many students use photographs of animals to copy from. This is all right; we can't have an elephant standing in the house waiting to be painted, so we have to compromise. But you must also sketch or paint animals from life where possible: you will get the feel of the animal, the way it walks and sits, the thickness of its fur, its colour, and so on. These are details you cannot observe just from a photograph, but if you use your real-life sketches and paintings with a photograph and your observation, then you can paint them. Naturally, if you are going to paint an animal that will keep still for you – such as a cat asleep on your favourite chair – then there is no need for photographs. So when you go out to paint animals, you are – until you have plenty of experience – going out to sketch, observe and learn. I suggest that you start by drawing them, and forget painting for the first few times. Use a cartridge paper sketchbook and a 2B pencil.

Say I am to sketch some heavy horses at a county show, I find when I start that I take 15–20 minutes to get my brain and pencil working to achieve any good drawings. It seems to take this length of time to become accustomed to the speed at which you have to

work, and the disappointment of getting half-way through a good sketch when the horse moves. Sometimes I'm sure they grin at me before moving off! I find that for the next half-hour or so I am working very confidently and producing some good work, but then for the next ten minutes my work seems to go off again. I think it is because my brain becomes tired by the concentration necessary to draw models that are continually moving. If I have a break for ten minutes, I can start the sequence again quite happily, except that this time it takes only a few minutes to get into good drawing. I have explained what happens to me to give you heart, because animals can be a very frustrating subject to work on 'in the field', and even professional artists have the same problems as students.

In the painting of the pigs (**fig. 129**), the first wash on the piglets was done with French Ultramarine and a little Crimson Alizarin, and when I got to their bottoms I added a mix of Cadmium Red and Cadmium Yellow Pale into the wet paint. This merged to give the effect I wanted. I added very little to them after that, just a slightly darker tone to show form. The dark grass around their bodies shows their shape (light against dark). Notice how the grass is painted very simply, with only a few horizontal brush strokes, but leaving some white paper showing in places (dry brush).

Sheep have a very simple shape to draw and paint,

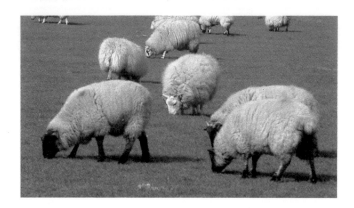

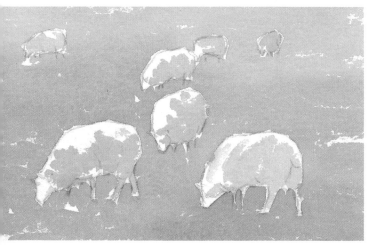

but when you come to put them in a painting they are not as simple as they appear. I think that because their shape is so simple, it is easy to make them look like a box; there is nothing much to model. For this reason it is very important that you go out and sketch them from life. In **fig. 130**, Stage 1 (painted with just a wash of Yellow Ochre, leaving areas of white paper) would be sufficient and not too over-simplified for some watercolour paintings. In the finished stage I added a second wash, a little darker, to show more form. When this was dry I worked over a third wash on the nearest sheep, including their heads, and finally added shadows. Notice that the outline of the sheep, made by the grass, is painted very freely.

The sketches in **fig. 133** are of some Highland cattle that I drew on cartridge paper with a 2B pencil, then painted. The photographs opposite (**figs. 131** and **132**) I took while I was there. This gives you an idea of how I work. I drew the cattle first, shading in the tones with pencil, then I painted a simple colour-wash over the drawing. The pencil shading shows through, adding tonal values. Notice how the pencil gives form to the hair on the cattle, helping to give it movement and life. When the wash was dry I added another darker tone very carefully, resulting in the final form and dimension. The sketch on the left of the second row, **fig. 133**, I painted without drawing first. It lacks a little shape and form, and the use of pencil would have helped it, but it's excellent practice. Try it.

Fig. 130 (left, top to bottom) Photograph; Finished stage; Detail. Whatman 200 lb Not, 20 × 13 cm (8 × 5 in)

Fig. 134 (below) Detail from **fig. 133** opposite

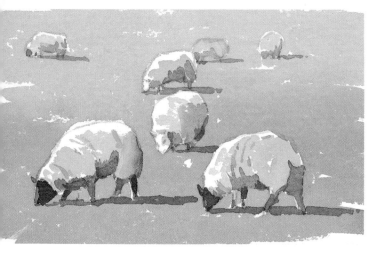

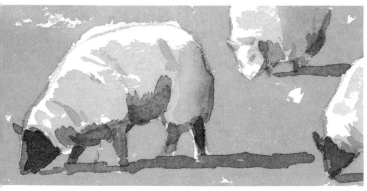

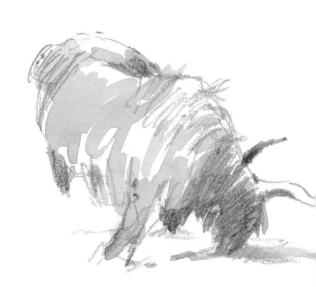

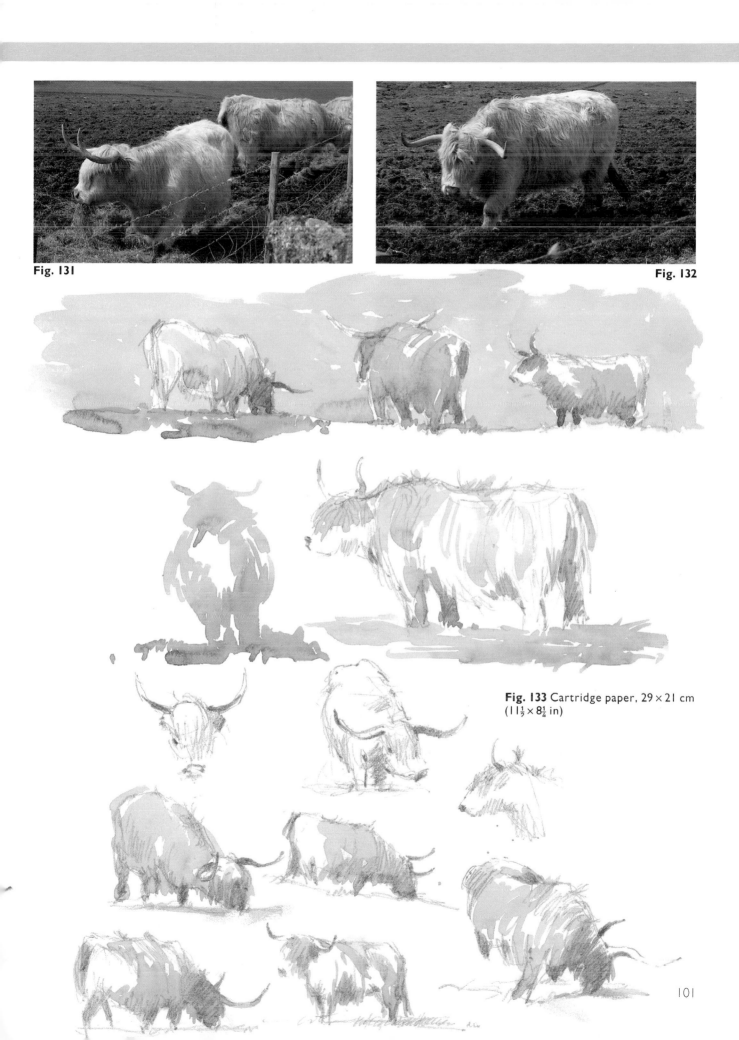

Fig. 131

Fig. 132

Fig. 133 Cartridge paper, 29 × 21 cm
(11½ × 8¼ in)

SIMPLIFYING PEOPLE

Fig. 135

Fig. 136 (below, left) Stage I

Fig. 137 (below, right) Finished stage. Bockingford 200 lb, 18 × 15 cm (7 × 6 in)

I don't need to tell you that artists have just as much trouble with painting people as they do with animals. In fact, when people are sitting down they change their position far more often that animals do. To practise, go where you will find a gathering of people – on the beach, at a sports event, and so on – and sit out of the way, observing and drawing them with a pencil. I don't mean you should draw large portraits of people, but the size that you would put them into a painting (middle distance); as part of the scene, as the centre of interest. Again, start simply, and as your confidence grows you will be able to put modelling into your figures. You do have one advantage with people: when they are not to be drawn in action, you can ask them to model for you. This means that they will keep still!

To start you off I have shown you in **fig. 138** a very elementary way to paint figures which could easily be put into any simply worked watercolour painting. Remember, the further away they appear in a painting, the less detailed they should be.

Look at the figures at the top right of **fig. 138**. These show four stages of painting a silhouette figure. First paint the head, then the body, the arms and the legs. This is done in one movement in a few seconds. This may sound simple but it needs practice. The three

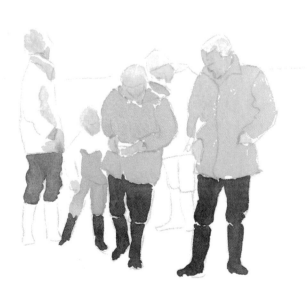

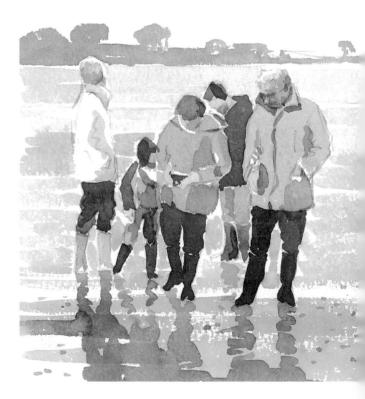

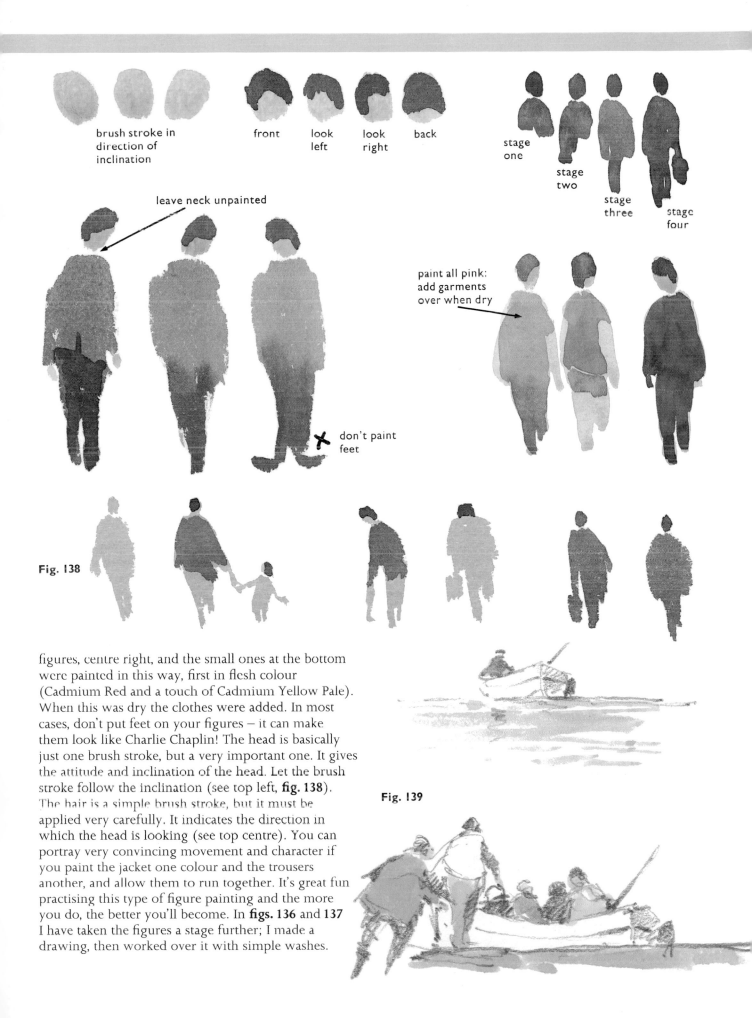

brush stroke in
direction of
inclination

front　look
left　look
right　back

stage
one

stage
two

stage
three

stage
four

leave neck unpainted

paint all pink:
add garments
over when dry

don't paint
feet

Fig. 138

figures, centre right, and the small ones at the bottom were painted in this way, first in flesh colour (Cadmium Red and a touch of Cadmium Yellow Pale). When this was dry the clothes were added. In most cases, don't put feet on your figures – it can make them look like Charlie Chaplin! The head is basically just one brush stroke, but a very important one. It gives the attitude and inclination of the head. Let the brush stroke follow the inclination (see top left, **fig. 138**). The hair is a simple brush stroke, but it must be applied very carefully. It indicates the direction in which the head is looking (see top centre). You can portray very convincing movement and character if you paint the jacket one colour and the trousers another, and allow them to run together. It's great fun practising this type of figure painting and the more you do, the better you'll become. In **figs. 136** and **137** I have taken the figures a stage further; I made a drawing, then worked over it with simple washes.

Fig. 139

In **figs. 141** and **142** I have taken people from the photographs reproduced on this page and simplified them. I drew them first with a pencil and then coloured them in very simply with just one or two washes. This method is more ambitious than the brush-stroke one on the previous page, because by drawing first you can put more form into the figure. Also, because you have drawn it, you have a little more time to consider its painting. As these washes are simple, if the person you have just drawn moves to another position, or even moves off, you can still see or remember the colours they are wearing. So with this method, the drawing is more important.

I had to paint these exercises from photographs in order to let you see the originals, so some of them are inclined to be a little tight. When you work from life, it is almost impossible for your painting to be anything other than free. It will do you no harm to work from photographs like these to practise, so long as you do work from life once you are becoming confident.

Figs. 143 and **144** on page 106 are two pages from my sketchbook, worked from life. At the top are two students in a poppy field, which I painted as a demonstration for other students. The drawings at the bottom are of children on the beach near my home.

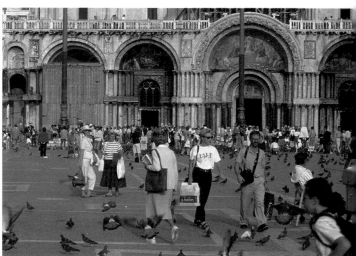

Fig. 140

Fig. 141 (opposite, above) Cartridge paper, 29 × 21 cm (11½ × 8¼ in)

Fig. 142 (opposite, below) Cartridge paper, 29 × 21 cm (11½ × 8¼ in)

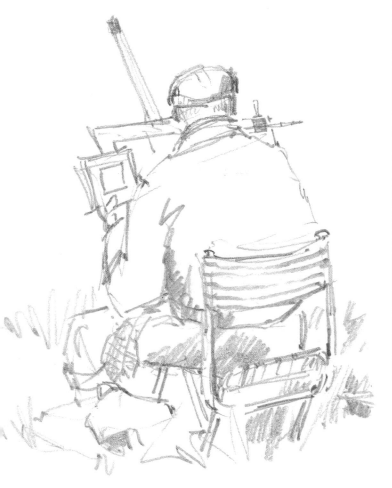

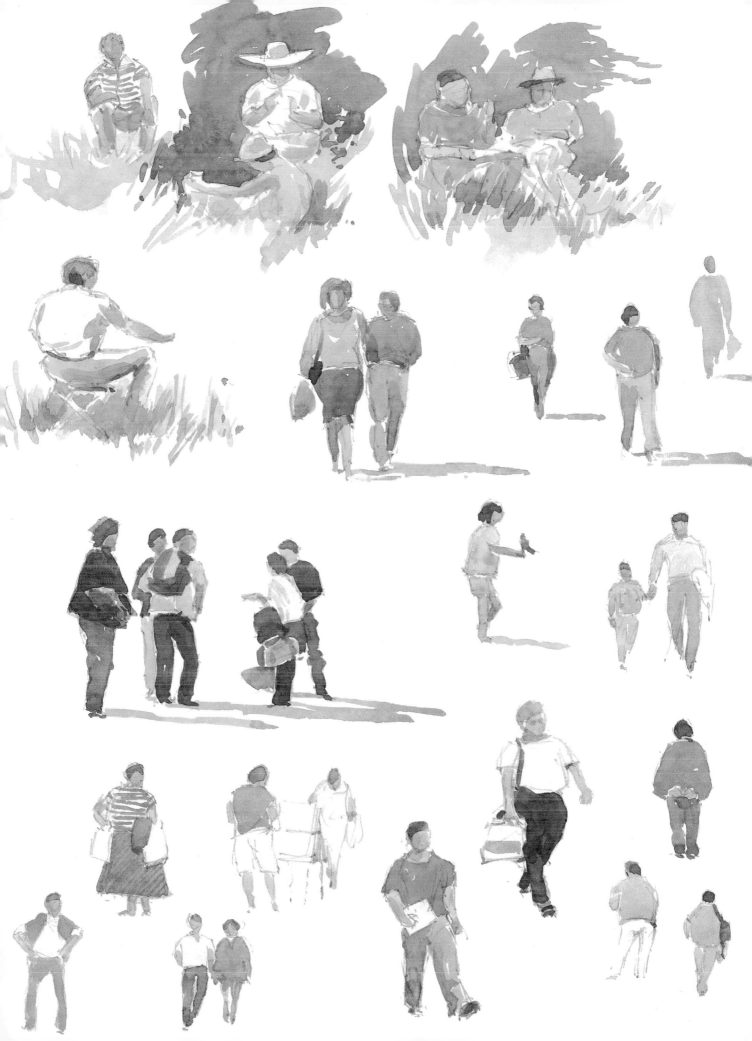

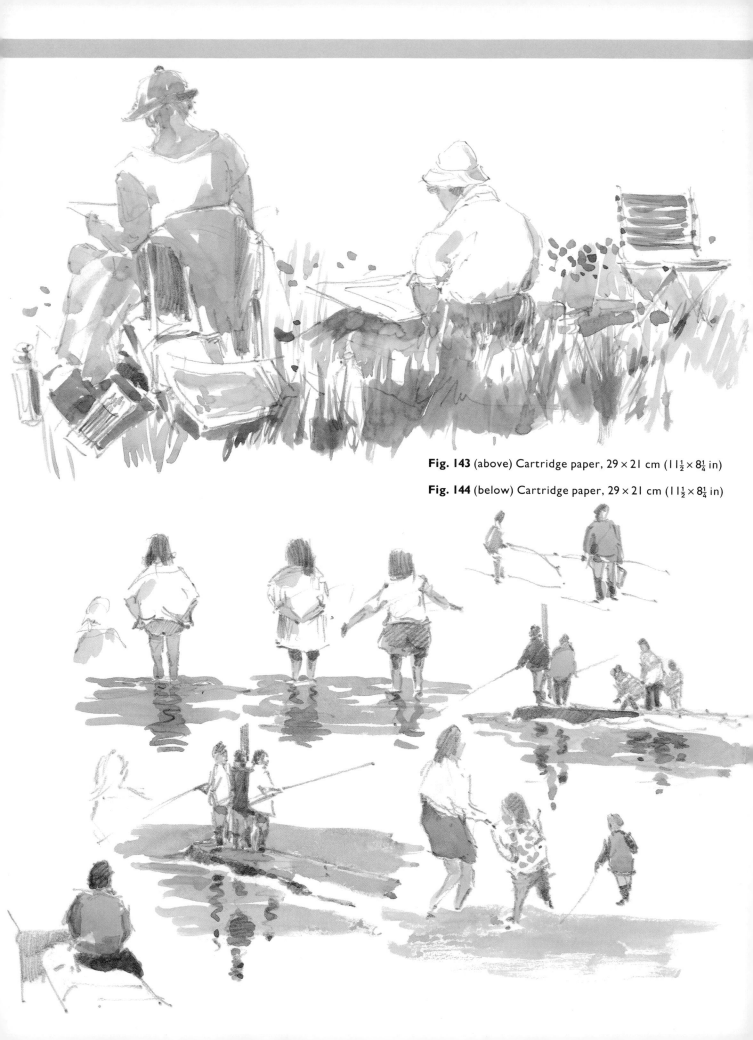

Fig. 143 (above) Cartridge paper, 29 × 21 cm (11½ × 8¼ in)

Fig. 144 (below) Cartridge paper, 29 × 21 cm (11½ × 8¼ in)

Part Six
USING YOUR PHOTOGRAPHS

PAINTING FROM A PHOTOGRAPH

Before we start this lesson, let me say that painting from a photograph is not a short cut to learning to draw or paint. A photograph is an **aid** to painting. If you accept this, then use a photograph to work from without feeling guilty as many students do. After all, put yourself in the position of the Old Masters. They couldn't paint at night because there was no electricity. Yet I am sure that if electricity had been available they wouldn't have scorned science; they would have worked at night with this 'modern wonder'. Similarly, I am sure they would have used a camera, taken photographs, and used them to help, together with their sketches, when they were working in the studio. Let the camera become just another tool, along with your sketchbook, electric light, modern nylon brushes, learn-to-paint videos, books, and so on.

Photography has its part to play, but beware – a photograph always 'flattens' the middle and far distance, making it look smaller and insignificant. When we look at the same view, our eyes can unconsciously enlarge the middle distance and we then see it in isolation; it fills our vision. When you work from a photograph you should keep this in mind. The best way to work is to draw a pencil sketch of a scene, then take a photograph. You will see the difference between your eye's image and that of the camera, and that experience and knowledge will help you.

Look at **fig. 147**. It is a sketch I drew in Rome, and **fig. 145** is the photograph I took at the same time.

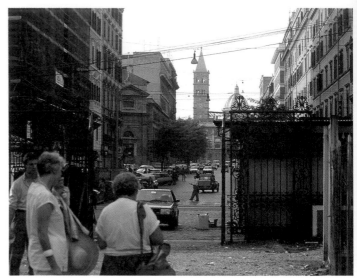

Fig. 145

Fig. 146 (opposite, above left) Cartridge paper, 29 × 21 cm (11½ × 8¼ in)

Fig. 147 (opposite, above right) Detail from **fig. 146**

Fig. 149 (opposite, below) Bockingford 250 lb, 38 × 23 cm (15 × 9 in)

Notice how I drew the sketch from the middle distance area, and how the photograph reduces it. Even with a telephoto lens, I find that distant landscape shots are flattened and lack the impact of your eye's image. Your eye selects what it wants to see, and how it wants to see it, but the camera can reproduce only what's there. (I speak as a person who uses a camera only for holidays and for reference. A professional photographer would no doubt do a far better job.)

I have used the photograph in **fig. 148** to paint from in the studio, and I couldn't have painted it much more simply (**fig. 149**). The water is white paper. From the sky to the foreground I have painted only one wash, running the colours together. When this was dry, I painted in the trees, one application only. Notice how I have simplified them, the building on the left, the telegraph pole, a darker tone on the right-hand bushes on the river bank and, finally, a few darker brush strokes on the foreground field. Notice also how I gave movement to the reflections and made the stones larger. I left out the reflection of the fence; it would have spoilt the simplicity of the water, which would not have been so convincing.

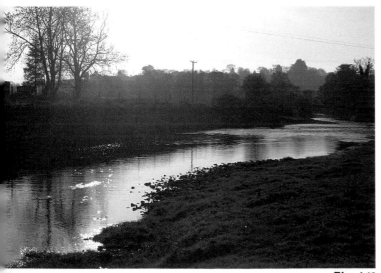

Fig. 148

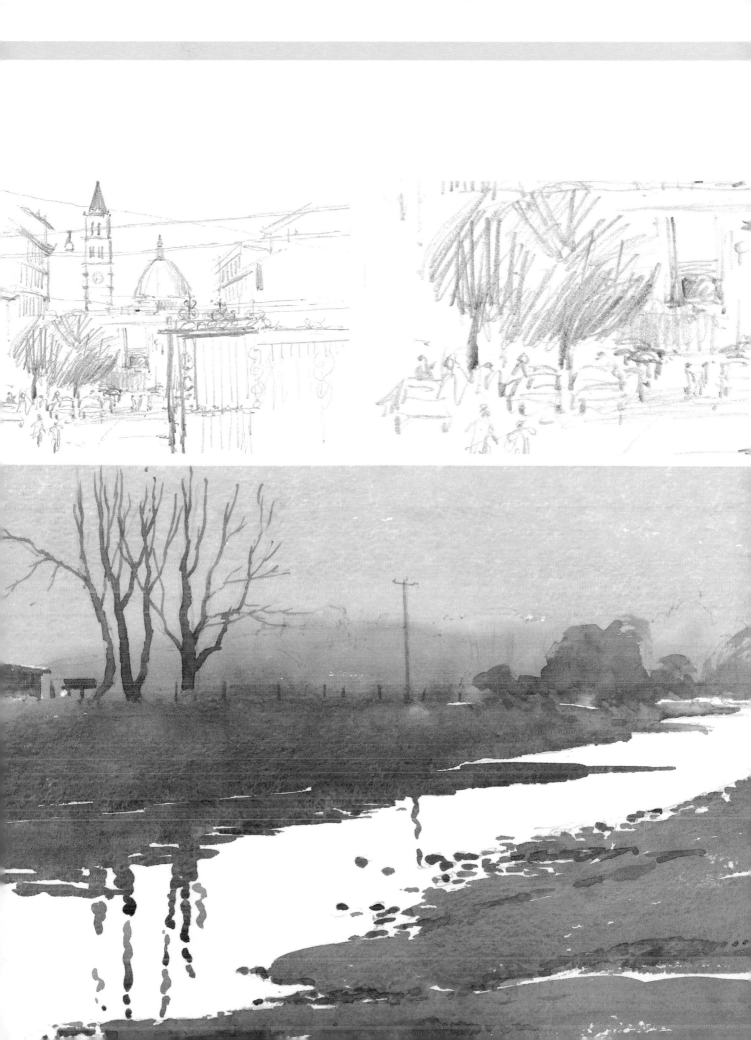

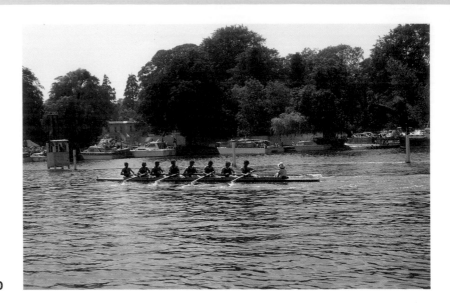

Fig. 150

Now try this exercise. First study the photograph (**fig. 150**) and the finished painting (**fig. 155**) on pages 112–13. The centre of interest is the front of the boat: the eye is led there because the boat is travelling that way. The buildings behind, with the moored boats, are ideal to help the composition. But I didn't want to paint all the trees in the background because they would dwarf the oarsmen. I also wanted plenty of water in the foreground. I started the composition just above the fir trees, thus eliminating the sky from the rest of the picture. Because I painted the sky only above the houses, the eye could follow through over the front oarsman, over the buildings and out of the picture. I also left out the 'hut' on stilts in the water to the left of the buildings: it would not have helped the composition.

Start by painting in the sky area, as I have done in Stage 1 (**fig. 152**). When this is dry, paint in the buildings, boats, and pink colour for the people on the river bank. Notice how simply this has been worked.

Don't try to paint exactly to your drawn pencil lines, or it will become laboured and tight. Then paint in the trees, working from left to right, changing the colour and contours very slightly to give a little form and shape. If the trees were made to look as detailed as they are in the photograph, they would be too strong for the boat, which is what the painting is about. Look at **fig. 152** just to see how freely I painted the trees around the house, figures and boats. All this was done using my No. 6 sable brush. In Stage 2 (**fig. 153**), first put a wash on the men and the boat, then paint the water. I decided to give more movement to the water and make much more of the reflections, which were almost non-existent on the photograph. Mix plenty of watery paint and, with your No. 10 brush, start at the far bank and work across and down the painting. At first, let the horizontal brush strokes touch and merge together, then allow larger areas of white paper to be left as your brush strokes get further away from each other and nearer to the bottom of the page. This gives

Fig. 151 (below) Detail from Stage 2, **fig. 153**

Fig. 152 (above) Stage 1

Fig. 153 (below) Stage 2

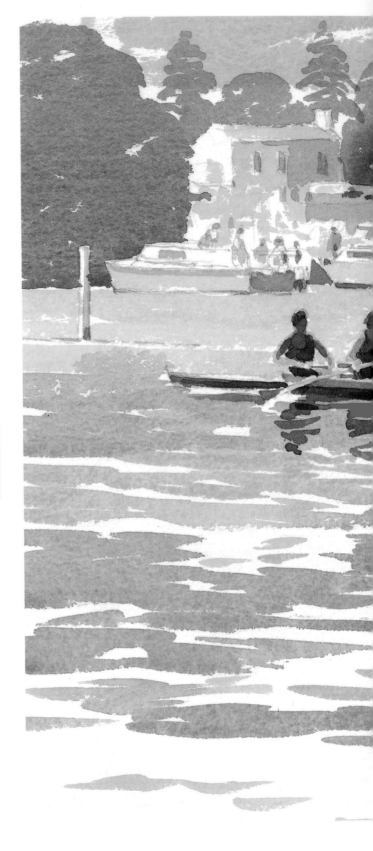

Fig. 154 Detail from the finished stage, **fig. 155**

Fig. 155 (right) Finished stage. Whatman 200 lb Not,
43 × 28 cm (17 × 11 in)

perspective, light and movement to the water. When
you are working under the men in the boat, let a little
flesh colour mix with your colours for the water.

In the finished stage (**fig. 155**), first paint the
T-shirts of the oarsmen and when they are dry, paint a
shadow over them, leaving some original flesh colour
unpainted, to give the illusion of sunlight. Then darken
the boat and paint in the reflections of the men. Notice
how I left white paper for the reflection of the cox at
the stern of the boat. Finally, put a few dark accents
into the buildings, the boats and the people in the
background.

I used my three main primary colours: Crimson
Alizarin, Yellow Ochre and French Ultramarine. I used
Hooker's Green No. 1 as the base colour for the trees,
and Cadmium Red with a little Cadmium Yellow Pale
added for the figures. I haven't explained how to mix
the colours for each part of the painting, because I feel
that by now you should try it on your own. I'm sure
you will succeed.

Part Seven
DEMONSTRATIONS

PEACEFUL HARBOUR

In these four demonstrations I have tried to give you a detailed account of how I painted the pictures. Naturally, to give you a brush-by-brush description is not practical, but I have analysed the stages of the painting and explained the most important features. At the end of each stage the paintings were photographed, to show how the work developed. Each stage represents a natural break in the painting, and you should always plan these breaks whenever you paint.

A natural break occurs when you can both stop the brush-work and allow the paint to dry. This gives you time (it may only be minutes) to look at what you have done, prepare mentally for what you are about to do, and take a rest!

Before you start each exercise, please read through the whole description and look at the illustrations to familiarize yourself with the painting. Do not try to copy my painting exactly, otherwise you will become too rigid and your work will not flow. Don't forget to allow your own style to flourish; by now it should be in evidence.

Stage 1
Use a 2B pencil and draw in the outline. Then, using your No. 10 sable brush and a watery mix of French Ultramarine and a little Crimson Alizarin, paint the sky, starting at the top of the picture, just as you did for a flat wash. As you work down the sky, add more water, Crimson Alizarin and Yellow Ochre to the mix. This will make the sky lighter and warmer, to give the atmosphere of early evening. Using the same colours, in different mixes, continue down the painting, leaving white paper for most of the water, the yacht sails and boats.

Stage 2
When the first wash is dry, using the same three colours and your No. 10 sable brush, paint in the roofs of the houses on the left of the big building; then continue with the windows in the large building, then the silhouette of the houses on the right (paint round some yacht masts), and continue with the distant hills, but don't paint over the yacht sails. Finally, paint a warmer wash (add a little more Yellow Ochre) for the houses on the left of the large building.

Stage 3
When the paint is dry, this time using your No. 6 sable brush, with the same colours but mixed a little darker, paint over the original wash on the houses. This brings them away from the background hills. Add more Yellow Ochre to your wash and paint the large building. When you are painting the houses and the building, work around the small boats on the harbour wall, leaving them white paper; and work around some of the yacht masts as you did in Stage 2. Finally, paint in the harbour wall, using a mix of French Ultramarine, Crimson Alizarin, Yellow Ochre and a little Hooker's Green No. 1. When you are painting the wall, work your brush strokes downwards. This allows any 'happy-accident' unpainted areas to appear as a natural form in the wall.

Stage 4
Now you are ready for the exciting part – painting in the mud of the harbour. This will give the water a definite shape and make it look like water, because the mud is dark and the water light (remember, dark against light). The effect will also be helped by the

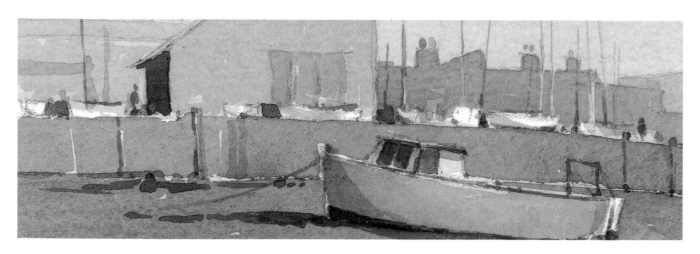

Fig. 157 (top to bottom) Stages 1, 2 and 3

Fig. 156 (opposite) Detail from the finished stage, **fig. 160**

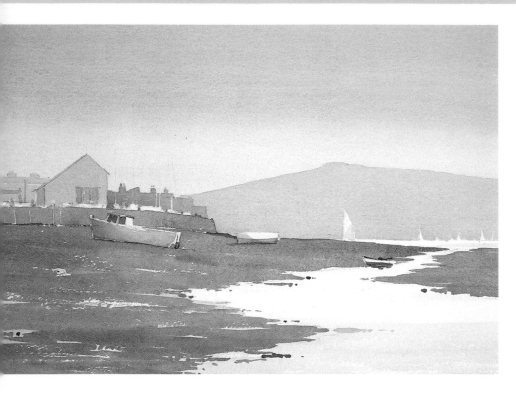

Fig. 158 Stage 4

visual fact that it is a harbour scene, where water is a natural element. The reflections to be put in later will complete the final illusion of water.

You must prepare mentally for this stage. You can't stop in the middle; you must maintain the flow of enthusiasm all the way to the bottom of the paper. Mix two washes side by side in your paint box palettes; use a mix of French Ultramarine, Crimson Alizarin and Yellow Ochre. But make one more mauve in colour (more blue and red) and one more brown (more yellow and red). Also, add some Hooker's Green No. 1 to each mix **as you paint**.

Now, with your No. 10 sable brush, start at the top

Fig. 159 (below) Use horizontal brush strokes and change colours as you paint down the picture

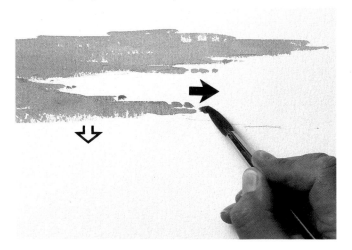

against the harbour wall and work to the right across the harbour and down, using horizontal brush strokes (see **fig. 159**). Leave some of the underpainting showing in places and this will look like water or light reflecting on the wet mud. Don't be afraid to change your colours as you work down the page (use Hooker's Green No. 1 for seaweed) and keep the paint wet and fluid. It's really like doing a flat wash, but changing colour and leaving some brush strokes showing. When this is dry, paint a warm grey wash on the two white boats (French Ultramarine, Crimson Alizarin and a touch of Yellow Ochre) and part of the white sail in the estuary. With a darker wash paint in the cabin windows of the large boat and define the small rowing boat near the water; and suggest a reflection, with two or three horizontal brush strokes.

Finished stage

The finishing stage of a painting always holds a different kind of excitement. It means that the painting has gone well and you have time to think and work out the last brush strokes, without panic! You are on the brink of seeing your own creation come to life. So here we go!

Using your No. 6 sable and rigger brushes at your discretion, put form and a little detail into the boats on

Fig. 160 (opposite, above,) Finished stage.
Whatman 200 lb Not, 53 × 34 cm (21 × 13½ in)

Fig. 161 (opposite, below) Detail from the finished stage, **fig. 160**

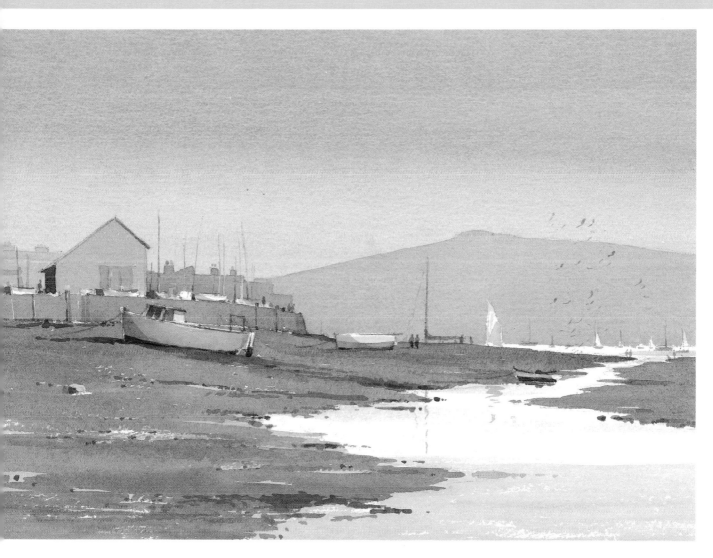

the harbour wall, the large yacht mast in the middle of
the picture and the small yachts in the estuary. Then
paint in the figures. Put in some detail on the boats,
and paint a darker shadow on the side of the large
building. Now paint in the reflection of the large mast
and yacht sail. Finally, add some darker tones to the
mud, and paint in the seagulls.

At this point your painting will have some areas to
be finished, but they won't be the same as in my
painting simply because your washes will have made
different shapes and tones. So look at your own
painting, and see where a few dark accents will help it
to read better and to sparkle.

TREES IN SNOW

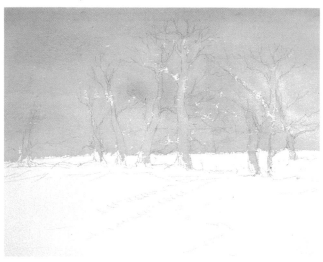

In Demonstration 1 you used white paper to help give the impression of water and here is another subject where you can take advantage of the white paper, this time to give the impression of snow.

Stage 1

Draw in the picture, using your 2B pencil. Wet the paper with your No. 10 sable brush, working down the sky to the bottom of the distant trees, and then paint over the wet sky area with a wash of French Ultramarine, Crimson Alizarin and Yellow Ochre. As the paint floods down, add more Yellow Ochre. Paint over the tree trunks, leaving white paper at the bottom of them to represent drifted snow.

Stage 2

With your No. 6 sable brush and a mix of French Ultramarine, Crimson Alizarin and a touch of Yellow Ochre, start at the left of the paper and paint in the row of middle-distance trees. When this is dry, using the same colours, paint in the two distant trees in the gap between the two foreground ones. Finally, with your No. 6 sable, and your rigger brush for the small branches, paint in the main trees, starting with the small ones on the left of the picture and working to the larger ones on the right. Use the same colours as the background trees, but make the colours stronger; also, add Hooker's Green No. 1 to the mix.

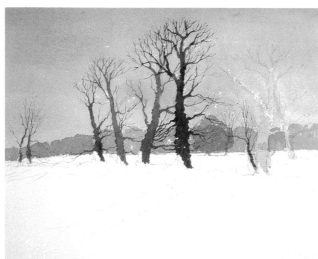

Stage 3

Start with the remaining two trees on the right and when these are dry, paint in the hedge with your No. 6 sable brush, using a mix of Yellow Ochre, a touch of Crimson Alizarin and a touch of Hooker's Green No. 1; in places add a little French Ultramarine. Leave white paper up against the tree trunks, to represent snow. Then, with the same colours work the tracks on the field; this will immediately make the field look flat. Finally, paint in the feathery branches on the trees, using your No. 10 sable brush and a wet- and dry-brush technique (see **fig. 165**).

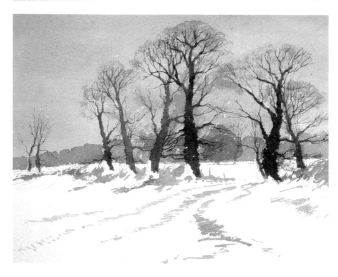

Fig. 162 (top to bottom) Stages 1, 2 and 3

Fig. 163 (opposite, above) Finished stage. Whatman 200 lb Not, 53 × 34 cm (21 × 13½ in)

Fig. 164 (opposite, below left) Detail from the finished stage, **fig. 163**

Fig. 165 (opposite, below right) Use your No. 10 sable brush to get the 'feathery' branches on the trees (stroke **j**)

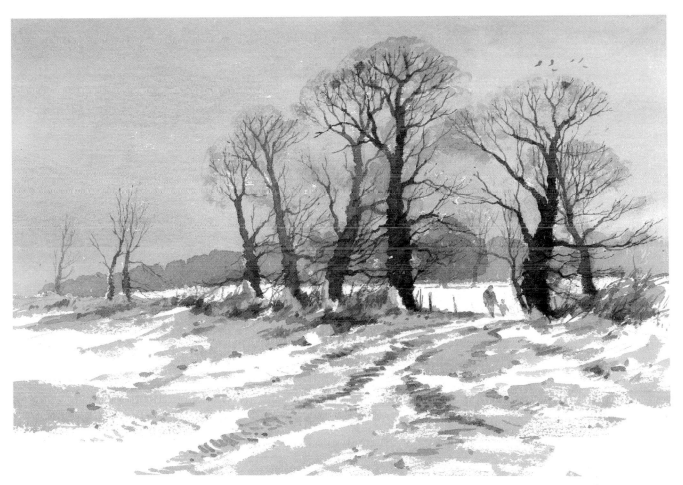

Finished stage

When the hedge and foreground are dry, work in some more modelling with a darker mix. Then add more branches to the trees. Now mix a wash of French Ultramarine, Crimson Alizarin and only a touch of Yellow Ochre and, with your No. 10 sable brush, paint in the snow shadow colour in the field. When this is dry, add some darker tones to give form. Now, with your No. 6 sable brush, paint in the two figures, paint the two main trees a little darker, and add the birds' nests and birds.

Look at your painting and decide where to put in your accents with darker paint. Don't overdo the work with your small brush at this stage or you will make it look laboured and tight, and you could spoil a good watercolour.

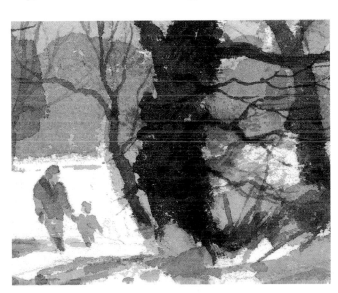

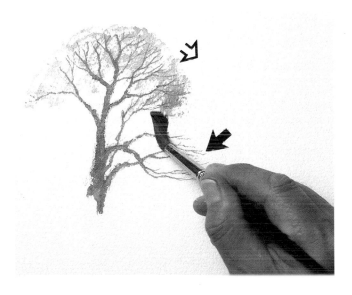

HALF-HOUR EXERCISE

For this half-hour exercise I chose a market scene in Florence, Italy. Don't panic! The drawing is not included in the time. Normally I would not put so much drawing into a half-hour work of this sort, but in this case I had to, to show you what I was doing and how I simplified it. Often, in a half-hour painting much of the drawing is done by the brush as things happen, especially in a scene like this where people, and sometimes objects, move. As I had to paint this picture in the studio from sketches and a photograph, it is much 'tighter' than if I had done it outside on the spot, where painting conditions would have been more hazardous, though the painting would have been much freer.

If you run over half an hour, don't worry; the time is set to keep you disciplined, and if you find you have to stretch it to 45 minutes, then that's OK, but don't make it an hour, or the object will have been lost. Get someone to time you.

Fig. 166 Detail from the finished stage on page 125

Stage 1

Draw the picture with your 2B pencil. If you prefer, put less drawing into it than I have done. If you were painting at the scene, the important element to put in, assuming your drawing was to be minimal, would be the archway at the end. Position this, then find your eye level (just on top of the people's heads) and then draw in the receding lines on the walls and ground.

Next, position the main stall with the canopy. While you were doing this you could suggest the people as they made interesting shapes and sizes in your composition. You could work from just this amount of drawing, or else add as much drawing as **you** felt necessary.

Stage 2

Using your No. 10 sable brush, with a mix of Yellow Ochre, Crimson Alizarin and a little French Ultramarine, paint in the walls and some of the suitcases in the foreground. Do this very freely – don't worry too much about keeping to your drawn lines.

Stage 3

Don't wait for the background to dry; carry on painting the gifts on the stalls. Continue with your No. 10 sable brush. Never worry if different colours run together as you paint your first washes. If you lose shape or form through this, when it is dry you can always recapture the form by adding shadows or darker tones. In fact, in a half-hour painting, this is the way it will happen because there isn't time for a colour to dry before another colour has to be painted up to it.

When you paint the gifts, work your brush strokes in the same direction as the gifts are standing or lying on shelves. This is important, as it helps to give an illusion of **ordered** chaos.

Keep your 'local' colours – yellow and red hats, brown suitcases, blue coloured boxes – the same strength. If you paint a strong red hat, for instance, it will stand out from everything else and spoil the painting. So keep all these colours roughly the same tonal value, but remember that they should look less and less colourful as they recede further into the distance.

Finally, with your No. 6 sable brush and a mix of French Ultramarine, Crimson Alizarin and a little Yellow Ochre, paint in some shadows on the stalls, starting with the underside of the large canopy, and work into the gifts areas. This helps to give the gifts shape and form.

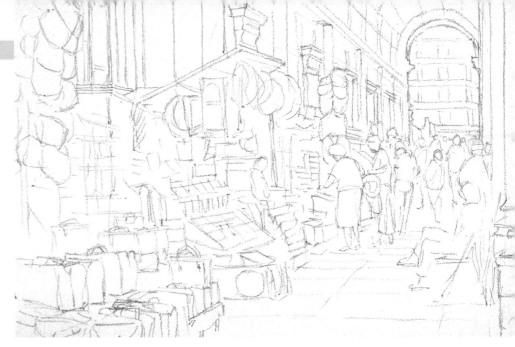

Fig. 167 (top to bottom) Stages 1, 2 and 3

Fig. 168 Stage 4

Fig. 169 (below) Give dimension to the display stands and gifts by painting a wash over the shadow area

Fig. 170 (opposite, above) Finished stage. Whatman 200 lb Not, 30 × 23 cm (12 × 9 in)

Fig. 171 (opposite, below) Detail from the finished stage, fig. 170

Stage 4

Use you No. 6 sable brush for all of this stage. Start by working the details on the roof of the archway and down the walls, with a mix of French Ultramarine, Crimson Alizarin and Yellow Ochre. Some of the shapes on the real walls were painted brown, so for these areas use less French Ultramarine in your mix. With the same dark colour paint in the pillars on the right of the picture. Now, with a weak mix of Cadmium Red and Cadmium Yellow Pale, paint in the flesh colour of the figures. Then paint very freely a suggestion of clothes on them; but notice how I left a lot of white paper to represent clothes as well. Now paint in the ground. Use a varying mix of French Ultramarine, Crimson Alizarin and Yellow Ochre. Paint with horizontal brush strokes and use some dry-brush technique as well.

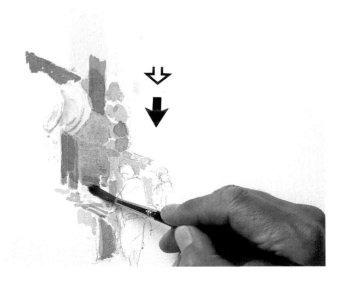

Finished stage

When I reached this stage I wanted the Stage 4 paint to dry. If I had been on location in Florence, it would have dried very quickly, but in the studio it didn't, so I used a hair drier. I frequently use this method of drying washes of paint for studio work. All you have to be careful about is not to start with the drier too close to your paper so that the air blows the wash over the paper! Try it on a spare piece of paper first.

When the Stage 4 paint is dry, mix a wash with French Ultramarine, Crimson Alizarin and a little Yellow Ochre. With your No. 6 sable brush, starting in the middle of the left-hand wall, paint a wash over the wall, round the arch and down the right-hand pillars. Also work it over the distant people. With the same wash paint over the side of the display stand to the right of the red, yellow and brown bags hanging on the wall. This gives dimension to the stand; also the panelled woodwork above. Then with the same wash paint over the gifts to the left of the main figure (see fig. 169).

Now add some dark accents where **you** feel you want them on **your** painting.

Finally, remember the 'standard' of your finished painting will be the best **you** can do in half an hour. Mine will be the best **I** can do in half an hour. Until you are confident with watercolour, it is not the quality of finish that matters but the actual fact of painting a picture in half an hour – for the discipline it imposes. But above all, it teaches you to **observe** and to **simplify** – two of the most important lessons to learn in painting.

Incidentally, my time was 34 minutes 20 seconds, not including the drawing. June stood over me, with the photographer, and timed me.

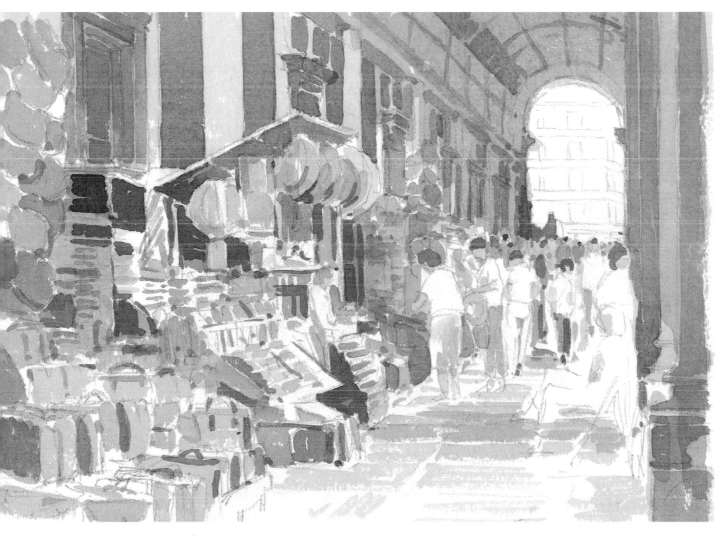

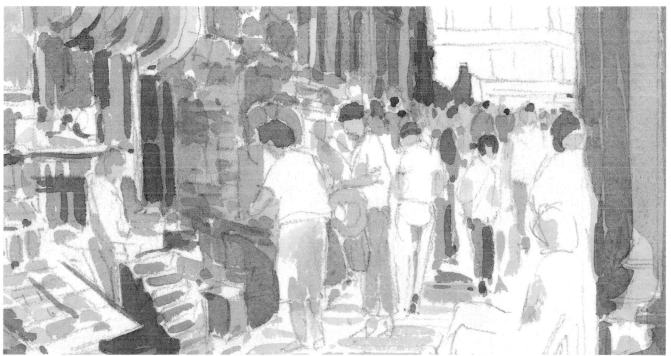

VENICE

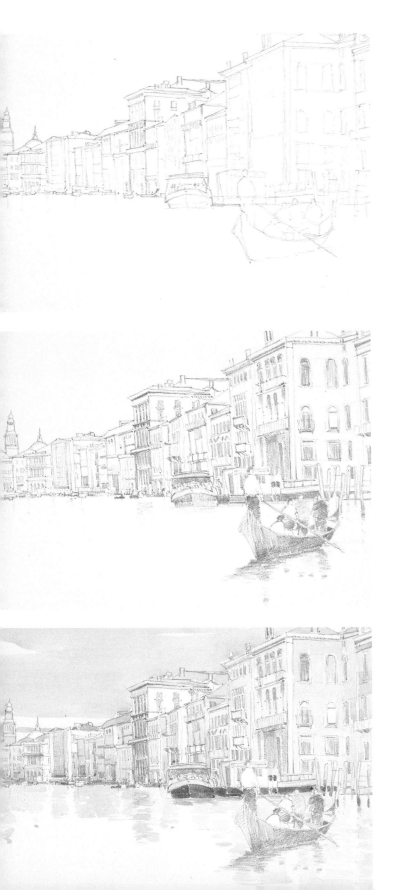

If you are worried about your ability to draw, then leave this exercise until you have had more drawing experience. But if you are excited about the subject, then have a go. You could do much better than you think.

Stage 1

Draw your water line in position (the bottom of the buildings) on your paper. Then draw the main building in the foreground, and the large building in the centre of the picture. When you are happy with their relative sizes and positions, and not before, go on to draw in the rest of the buildings. If these two major positions on the drawing were wrong and you drew all the other buildings, the latter would not fit into place, and you would have wasted a lot of energy and time; when you are working outside, time is precious.

Now draw in the gondola. If you were on location, you would not have time to put any detail into the gondola as it came into **your** scene, but you could position it and then when another came along you could pick out the parts you had missed; or you might see, moored nearby, some other gondolas to work from.

Stage 2

Continue to finish the drawing and then shade in some areas to give tonal contrast (light against dark). Start at the left-hand end and work to the right if you are right-handed, to avoid smudging the pencil with your drawing hand. Shade in the windows, the boats and the jetty; the black cruiser – which is a water bus – at the end of the jetty, and finally the gondola with its gondolier and passengers, and its reflection.

Stage 3

With your No. 10 sable brush, mix French Ultramarine and a little Crimson Alizarin, and paint in the sky. Then with your No. 6 sable brush, paint in the buildings. Prepare two watery mixes: Yellow Ochre and Cadmium Red in one palette, and Crimson Alizarin and French Ultramarine in another, then paint in the buildings, changing colours as you work each one. You can add colours to the palettes as you work. Leave some white areas of paper to represent buildings as well. With roughly the same colours, paint in the reflections of the buildings, and paint the yellow board around the water bus.

Fig. 172 Top to bottom: Stages 1, 2 and 3

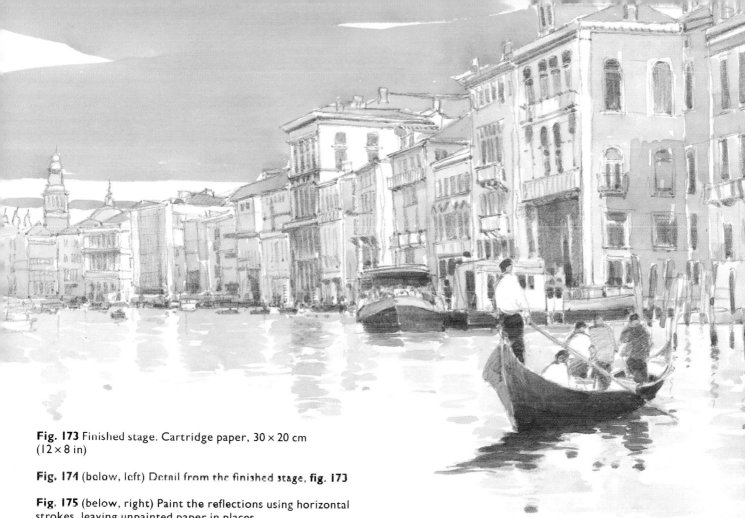

Fig. 173 Finished stage. Cartridge paper, 30 × 20 cm (12 × 8 in)

Fig. 174 (below, left) Detail from the finished stage, **fig. 173**

Fig. 175 (below, right) Paint the reflections using horizontal strokes, leaving unpainted paper in places

Finished stage

Using your No. 6 sable brush, paint the gondola and the people in it, and the shadow under the canopy of the water bus. Now, with a mix of French Ultramarine, Crimson Alizarin and Yellow Ochre, paint in the shadow on the side of the main foreground building and underneath the balcony at the front. Now paint over the pencil reflection of the gondola with a dark mix of French Ultramarine, Crimson Alizarin and a touch of Yellow Ochre. Then look at **your** painting and add any dark accents it needs to make it sparkle.

Beware! Do not over-work with paint on cartridge paper or you will start to pull up underlying washes, and the painting could become muddy.

One final point: the colour of the water in Venice was nearly always blue. But I decided to leave white paper for this painting, as I thought the blue would be too strong for the delicate pencil-and-wash technique. What do you think?

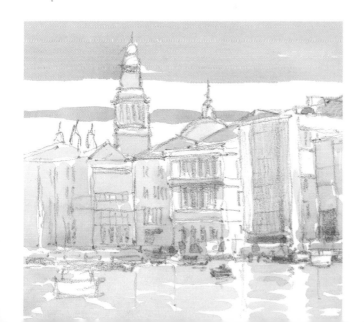

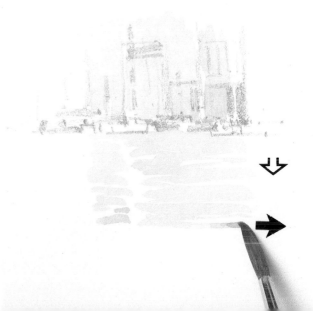

Part Eight
GALLERY

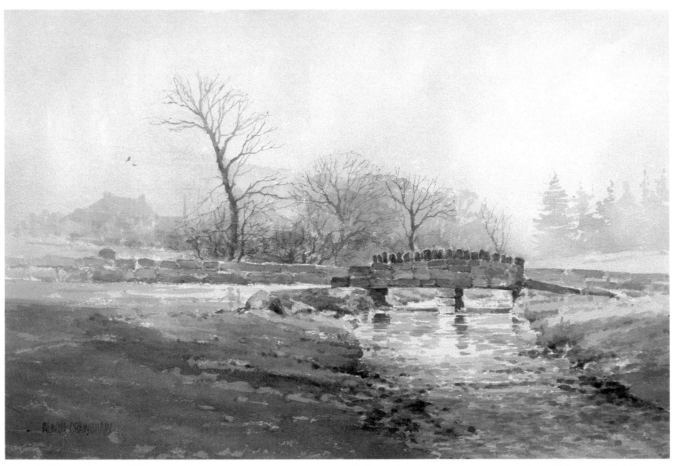

(above) *Wet and misty*. Whatman 200 lb Rough, 48 × 36 cm
(19 × 14 in)

(below) *Bright and blustery, Topsham*. Whatman 200 lb
Rough, 48 × 36 cm (19 × 14 in)

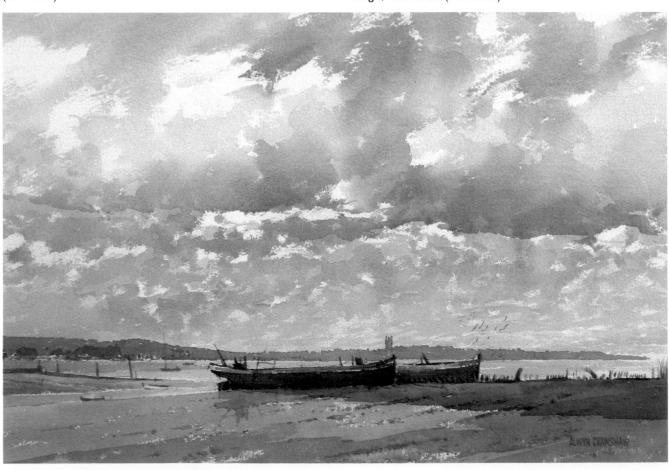

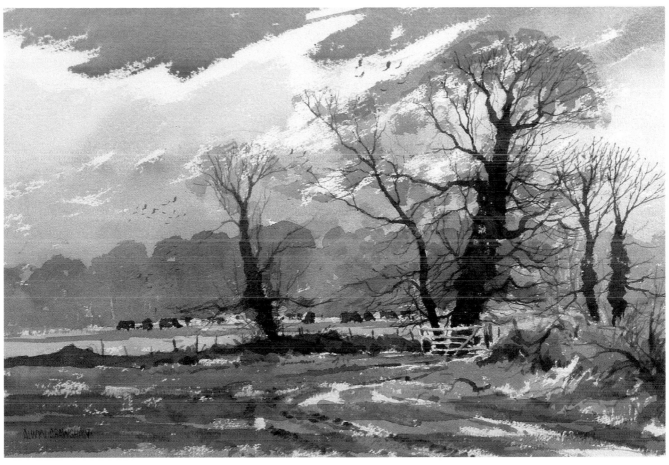

(above) *Bright intervals*. Whatman 200 lb Rough, 48 × 36 cm
(19 × 14 in)

(below) *Dartmoor diehards*. Whatman 200 lb Rough,
48 × 36 cm (19 × 14 in)

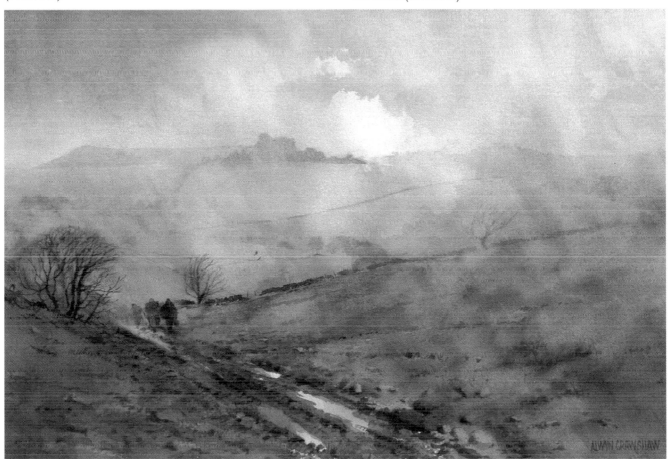

The changing face of Dartmoor. Whatman 200 lb Rough,
48 × 36 cm (19 × 14 in)

ALWYN CRAWSHAW

(above) *From the citadel, Forcalquier, Provence.* Cartridge paper, 29 × 21 cm (11½ × 8¼ in)

(below) *Becky Falls, Devon.* Whatman 200 lb Rough, 48 × 36 cm (19 × 14 in)

INDEX Page numbers in **bold** type refer to photographs and illustrations